IMAGES
of America

BRIDGEPORT

D1597689

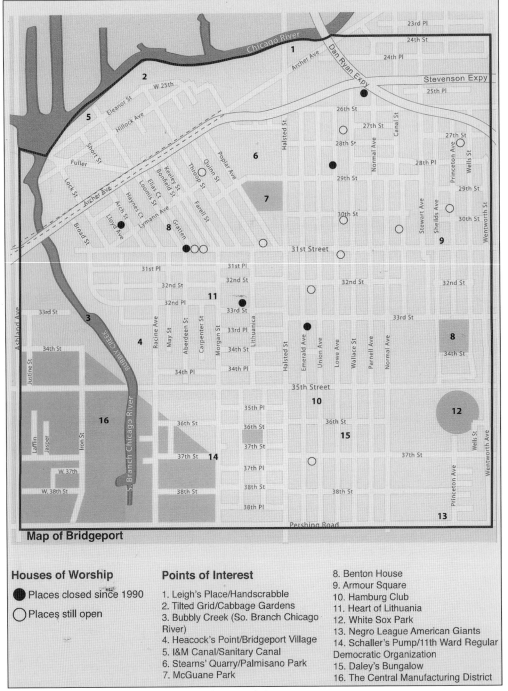

Map of Bridgeport

Houses of Worship
- ● Places closed since 1990
- ○ Places still open

Points of Interest
1. Leigh's Place/Handscrabble
2. Tilted Grid/Cabbage Gardens
3. Bubbly Creek (So. Branch Chicago River)
4. Heacock's Point/Bridgeport Village
5. I&M Canal/Sanitary Canal
6. Stearns' Quarry/Palmisano Park
7. McGuane Park
8. Benton House
9. Armour Square
10. Hamburg Club
11. Heart of Lithuania
12. White Sox Park
13. Negro League American Giants
14. Schaller's Pump/11th Ward Regular Democratic Organization
15. Daley's Bungalow
16. The Central Manufacturing District

This is a map of Bridgeport. (Map by Julia Joseph.)

ON THE COVER: Bridgeport citizens parade on Halsted Street in 1959 in support of the reelection of Mayor Richard J. Daley, (Courtesy of Jack Lenahan.)

IMAGES
of America

BRIDGEPORT

JoAnne Gazarek Bloom,
Maureen F. Sullivan, and Daniel Pogorzelski

ARCADIA
PUBLISHING

Published by Arcadia Publishing
Charleston, South Carolina

Printed in the United States of America

Library of Congress Control Number: 2012933627

For all general information, please contact Arcadia Publishing:
Telephone 843-853-2070
Fax 843-853-0044
E-mail sales@arcadiapublishing.com
For customer service and orders:
Toll-Free 1-888-313-2665

Visit us on the Internet at www.arcadiapublishing.com

*This book is dedicated to the devotion, understanding,
and hard work of Rob Warmowski, Christopher Bloom,
Marek Dobrzycki, Julie Joseph, and Benton House.*

CONTENTS

INTRODUCTION

Most Chicagoans will tell you that Bridgeport means the 11th Ward, the Irish and machine politics. Most Chicagoans would get an argument from Bridgeport folks. Half-truths, they will say, notions that do not comprehend the energy of a neighborhood that forged the city, transformed the nation, and saved the world. No, really.

Bridgeport has dibs on being Chicago's oldest neighborhood. Officially, Bridgeport runs north from the Chicago River to 39th Street on the south, and from Canal Street on the east to the Chicago River, as it curves south and west. Unofficially, Bridgeport has a much larger footprint. Its western edge extends to Ashland Avenue. On the east, it boundaries include Armour Square, the land over the Canal Street railroad viaducts. The city maps show Amour Square as a separate area. On the other hand, *The Encyclopedia of Chicago* scoffs at a "neighborhood" status: "Armour Square is merely an assemblage of leftovers from adjacent communities." Armour Square is no leftover. The pudding's proof: Residents readily admit they are from both Armour Square and from Bridgeport. Ask them.

Bridgeport began as a shortcut for French voyageurs. In 1673, Marquette and Jolliet, canoeing up the Mississippi River back to Canada, altered their route home. They bypassed the Wisconsin River and instead took the Illinois River to Des Plaines, then portaged a small mud lake to the South Branch of the Chicago River and on to Lake Michigan. Jolliet was intrigued; the passage had economic potential. A canal, eliminating the portage, could easily link the western rivers, the Great Lakes, and the Gulf of Mexico. In his official report of the journey, he urged the king of France to secure the area for such a project.

Engineering breakthroughs in construction—innovations that had canals cut through mountains and alter river courses—caused a frenzy in canal building in western Europe. America was bitten by the same bug. In 1818, when Illinois became a state under the 1783 Northwest Ordinance, Nathaniel Pope, Illinois's Congressional delegate, managed to reshape Illinois's state boundaries with Jolliet's canal in mind; Illinois' northern boundary was moved 62 miles, grabbing from Wisconsin both the Port of Chicago and the South Branch of the Chicago River. The canal could now be built in one state, Illinois.

Earlier, in 1803, the United States government established Fort Dearborn at the mouth of the Chicago River at Lake Michigan. Two miles southwest of the fort, "Leigh's (or Lee's) Place," James Leigh's farm, supplied food to both the fort and nearby settlers. It was Chicago's first neighborhood, Bridgeport's forerunner, situated at 24th and Throop Streets.

By 1812, tension between Native Americans, the fort, and some settlers increased. In August, the garrison abandoned Fort Dearborn for the safety of Fort Wayne, Indiana. They got as far as what is now 18th Street and Prairie Avenue when attacked in what is now called the Fort Dearborn Massacre. James Leigh, his son John, and his 10-year-old daughter, Lilly, died in the melee. Around 1816, Leigh's Place became a fur trading post, called "Hardscrabble." In 1827, Chicago's first lawyer, Russell Heacock, opened Chicago's first saloon near 35th Street and Racine Avenue.

Amidst all this, no one forgot the potential of Jolliet's canal. In the wake of the Erie Canal in 1825, the push to build Jolliet's Illinois & Michigan Canal began. In the 1830s, the Irish Erie Canal workers, with their hard-earned skills, shovels, and truck gardens, arrived. They settled

along the banks of the South Branch near Ashland. Around 1830, Hardscrabble became known as "Cabbage Gardens."

The new canal opened in 1848, providing that easy route from the Mississippi River to the Port of New York. The flow of national commerce dramatically changed. Transport of goods usually followed a southern route, down the Mississippi River, through St. Louis on to New Orleans, then via the Gulf of Mexico and Atlantic Ocean up to New York, and finally on to Europe. Insurance—especially for the voyage from New Orleans to New York—was expensive. By contrast, canal freight insurance was cheap. Soon, the national mercantile axis became a west-to-east run, shifting economic and political balance north.

The South Branch Township emerged as the preeminent western port. From 1836 on, it came to be called "Bridgeport." Some claim the name came from a bridge at Ashland Avenue; but others point out that the Ashland Bridge was built long after Bridgeport became common parlance. Today, historians believe that *Bridgeport* beat out the name *Canalport* in a real estate marketing war. Bridgeport Township became an official Chicago neighborhood in 1863.

Industry boomed in Bridgeport, a fusion of its location and indifference to environmental consequences. In 1830, Stearns' Quarry at 29th and Halsted Streets started dynamiting the earth for limestone to line Chicago's harbors and canal, to provide Lake Michigan breakwater, and to make beautiful building facades. The quarry continued blasting until 1969. A slaughterhouse began butchering in 1850; others joined. Tanneries and glue factories followed. Rolling mills, ironworks, granaries, shipyards, and cooperages operated. In 1905, the city fathers and major businesses established American's first privately owned and managed industrial park, the Central Manufacturing District ("CMD"). The CMD business owners put in their own roads and utilities, developed fire and police departments, built a private commercial bank and gentlemen's club. A. Epstein oversaw all building design.

More immigrants, eager for jobs, arrived: Irish, German, Czechs, and Norwegians; then Swedes, Poles, Lithuanians, Jews, Greeks, Canadians, a Russian or two, Croats, Dalmatians, Italians, and even folks who traced their ancestors to the *Mayflower* and the *Golden Hind*. By 1900, Mexicans, working on the massive rail yards surrounding the neighborhood, settled in. Bridgeport's 1900 population of 32,000 doubled by 1920, and 36 percent were foreign born. By the turn of this century, Chinese and other Asians as well as a variety of Hispanics and African Americans joined the demographics. The old rules stayed, though: Pronouncing a name wrong means risking one's life.

Business catering to this mix grew along Archer Avenue, then Halsted, Wallace, Morgan, and 26th Streets. Churches sprang up, one or two or more for each ethnic group. Appended to the churches were schools, funeral parlors, and ethnic clubs. The Chicago Park District scattered recreational facilities throughout the area. Saloons appeared, one for each corner, and welcomed all.

Bridgeport clanged with tongues and roared with battles, both Old-Country holdovers and new brawls native to America. By the mid-1800, though, most of the ethnic groups did gather around one issue, the oppression of workers by industry. Bridgeport and neighboring Pilsen exploded with labor strife. The first strike was held by canal workers in 1845. In 1867 and 1877, Archer Avenue flared with parades of thousands of torches seeking the enforcement of an eight-hour day. The famous Battle of the 16th Street Viaduct and Red Bridge was manned with protestors from Bridgeport and Pilsen. Thirty workers died. In 1886, Bridgeport citizens participated on both sides of the Haymarket Riot.

Seeking political power, rather than protest to solve problems, Bridgeport organized into the swaggering 11th Ward after 1900. Local Irish residents became the perfect politicians for Chicago. They spoke the English of the Protestant establishment but prayed to the Catholic God of most of their immigrant neighbors. Bridgeport became a powerful force in government, honing the Democratic machine known today and producing five mayors, steadfast precinct captains, and lots of patronage jobs, and wielding national political influence.

Some say the first Bridgeport-born mayor, Ed Kelly, fearing war in Europe, engineered an unprecedented third presidential term for Franklin Delano Roosevelt in 1940, an act by which

many claim that Kelly "saved" the world. During the 1950s and 1960s, both Republicans and Democrats held numerous national nominating conventions in Chicago at the International Amphitheater. Not by coincidence, the road to the conventions literally went through Bridgeport. Thousands lined Bridgeport's streets watching presidents and other prominent politician pass their houses, including Dwight Eisenhower, Richard Nixon, Adlai Stevenson, Harry Truman, John and Robert Kennedy, Barry Goldwater, Lyndon Johnson, Joseph McCarthy, Hubert Humphrey, Sam Rayburn, Everett Dirksen, Ronald Reagan, and Jimmy Carter. Bridgeport for a time was a road to the White House.

Bridgeport politics so mesmerizes that other events are overlooked. The 1871 Great Fire never blazed south of the river. To walk though Bridgeport today is to glimpse parts of a city as it looked a century ago. Many streets still follow the "tilted grid" set up in 1836 by Col. William Archer, streets aligned with the river and buffalo path which is now Archer Avenue, defying Chicago's organized quadrants with their own private logic (all streets are designated "south" even though they might run east/west).

In the mid-1800s, Chicago raised the city streets to a uniform level. Most Bridgeport householders could not afford the expense of raising their homes to meet the new street level. To this day, the old "first floors" (once street level) are now basements, with deep front yards that are also at the old street level. The underground spaces between the new street levels and the old are called (in Polish) "*Joe Podsajdwokiem*" ("Joe under the sidewalk") and make fine space for coal bins, storage, and outhouses.

Enclaves within Bridgeport had their own private names. Only in Bridgeport would a slice of streets that is an Italian stronghold be called "Chinatown" or would the Irish live in German "Hamburg." "Polish Patches," bigger than some Polish towns, encompass St. Barbara and St. Mary of Perpetual Help Parishes. The "Heart of Lithuania" reminds its residents that it is the birthplace of Lithuanian Chicago.

Today, Bridgeport's population holds steady at 32,000. The neighborhood, along with Bronzeville, Pilsen, and Taylor Street, is part of the South Side Renaissance. It has the White Sox, famous artist studios, intriguing manufacturers, Michelin-rated restaurants, hip saloons, maybe a mob crew or two, new houses, and remodeled lofts. The old Stearns' Quarry is Palmisano Park, with a legitimate city mountain, waterfalls, fishing ponds, and vistas of skyscrapers. There is a Buddhist temple abiding next to a Benedictine monastery.

Yet, beneath the budding patina of updated architecture, young professionals, and artists, Bridgeport streets still whisper of a storied past. The gangways and prairies hold mysteries. Longtime residents, like their relatives before them, continue to stoop-sit on summer nights to learn what's what. Listen carefully, and you might learn a thing or two about the soul of the city.

One

How Bridgeport Shaped Chicago

In 1848, the Illinois & Michigan Canal ("I&M Canal") opened, realizing Louis Jolliet's dream to incorporate the Great Lakes in continental shipping. Bridgeport was its linchpin.

In 1673, explorers Louis Jolliet and Jacques Marquette, canoeing the Mississippi River back to Canada, took a shortcut up the Illinois River, portaging to the Chicago River's South Branch and to Lake Michigan. To Jolliet, this passage portended riches: "We could go with facility [from Canada] to Florida . . . by very easy navigation. It would only be necessary to make a canal, by cutting through . . . prairie to pass from [Lake Michigan] . . . to the [Illinois] River."

In 1809, Leigh's Place, a farm, stood on the prairie near Fort Dearborn, in what is now Bridgeport. When Leigh, his son, and daughter died in the Fort Dearborn Massacre, Detroit merchants Conant and Mack turned the farm into a fur-trading post called "Hardscrabble."

Nathaniel Pope, a territorial representative, pursued Jolliet's canal along with Illinois statehood in 1818. He persuaded Congress to move the state line 62 miles north, grabbing from Wisconsin Chicago's port and the river's South Branch for Illinois and the canal.

By 1836, the canal commissioners started laying out the area's streets to parallel the river and Archer Avenue, then a buffalo path. To this day, those streets, called a "tilted grid," defy Chicago's orderly quadrants. Several odd-shaped houses in Bridgeport, built to tilted grid specifications, still stand, angular and defiant, without a 90-degree angle in them. One, near the canal, has no right angles at all.

Irishmen who dug the Erie Canal brought their backs and shovels to dig the ditch for a dollar a day, a shanty, and a vegetable patch. Hardscrabble became "Cabbage Gardens." In 1830, a quarry began producing limestone to build the canal and restore the harbor.

The I&M Canal transformed America. Goods that had traveled a southern route—the Mississippi to New Orleans, then on to New York's port—now traveled through the I&M, the Great Lakes, and the Erie Canal to New York, creating a new west-east national market, with Chicago at its economic center.

In 1863, Bridgeport formally became a neighborhood of Chicago.

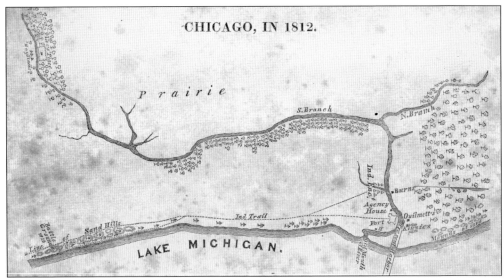

CHICAGO, IN 1812.

This is a map of Chicago in 1812 at the time of the Fort Dearborn Massacre. The fort, on the shore of Lake Michigan, was meant to protect the settlers who lived around it. Leigh's Place, located several miles southwest of the fort in what is now Bridgeport, is located in a grove of trees on the map's left side. It supplied food to settlers and soldiers. Julia Kinzie, daughter-in-law of John Kinzie, a Chicago pioneer, commissioned this map as part of her memoirs of the massacre. In 1816, a fur-trading post, known as Hardscrabble, succeeded Leigh's Place. A few years later, in 1827, Chicago's first lawyer, Russell Heacock, moved to what is now 35th Street and Racine Avenue and opened Chicago's first tavern. By 1833, thanks to the truck gardens of the Irish Erie Canal workers, Hardscrabble became known as Cabbage Gardens. (Courtesy of Newberry Library, Case Ruggles 209.)

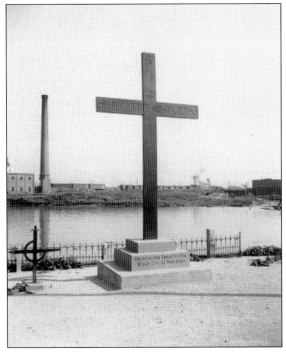

In this 1909 photograph, a tall cedar cross and a smaller iron one stand at 27th Street and Damen Avenue, just outside Bridgeport. Both memorialize Marquette and Jolliet's 1673 journey, navigating the Mississippi and Illinois Rivers, portaging to the Chicago River, and canoeing Lake Michigan home to Canada. Most importantly, the crosses honor Jolliet's prophecy that a canal, replacing the portage and connecting the waterways, could bring bounty to the region. (Courtesy of Chicago Public Library.)

The house at 1401 West Fuller Street (corner of Grady Court) aligns to surrounding streets, with outside walls parallel to Bridgeport's tilted gird. That grid, patterned in the 1830s when the canal digging began, follows the logic of the river and Indian trails, not what Burnham's 1909 *Plan of Chicago* calls the "rectilinear street system." The house is without a 90-degree angle. (Courtesy of Marek Dobrzycki.)

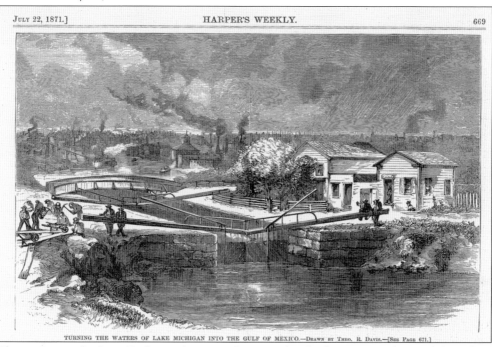

TURNING THE WATERS OF LAKE MICHIGAN INTO THE GULF OF MEXICO.—DRAWN BY THEO. R. DAVIS.—[SEE PAGE 671.]

The common tale about Bridgeport's name relates to a low bridge crossing the south branch of the river at Ashland Avenue. Heavily laden barges coming from the southwest had to unload and reload at this location, called the "port." This 1871 sketch depicts such a scenario. Historians discount this tale. A real estate marketing duel between a developer of "Canalport" and the canal commissioners left the commissioners winning with their name, *Bridgeport*, for the neighborhood. (From *Harper's Weekly*, July 22, 1871, courtesy of Chicago History Museum.)

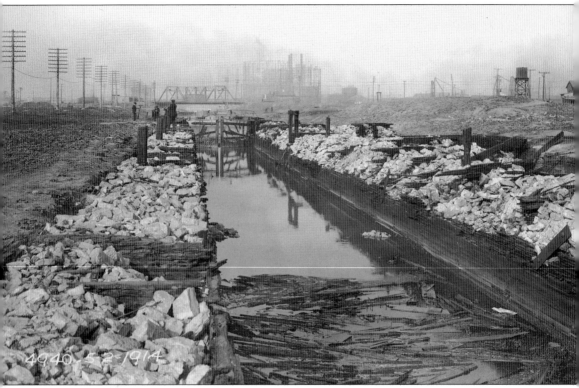

This photograph dates from no later than 1914 and shows the lock that once existed at Ashland Avenue. It indicates the appropriateness of the newly built Canal Origins Park, opened in 1996. This memorial on Ashland Avenue, close to the location of the lock, is a large green space dedicated to the vision of Marquette and Jolliet as well as the labor of the men and women who built the original canal. (Courtesy of *The Lost Panoramas: When Chicago Changed its River and the Land Beyond.*)

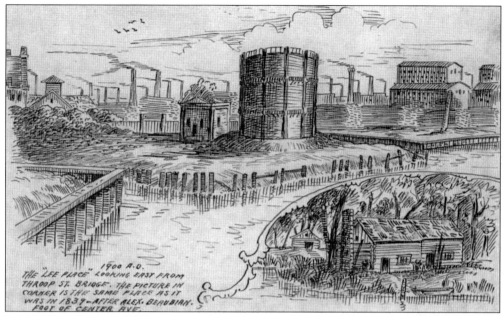

Leigh's Place (built in 1809) and later the trading post Hardscrabble stood on the banks of the South Branch of the Chicago River at present-day 24th and Throop Streets. This drawing depicts the area as it appeared from the Throop Street Bridge in 1900, with an 1839 sketch by Alex Beaubien in the right corner. (Courtesy of Chicago History Museum.)

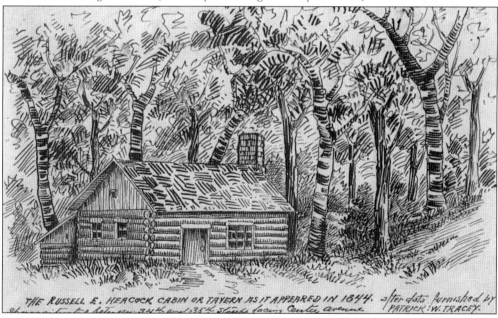

Russell Heacock arrived in Hardscrabble in 1827. He held many firsts: Chicago's first attorney (1816 license) and first tavern keeper (1830 license), provided that his saloon stayed "five miles from Chicago." It stood at Heacock's Point, now Racine Avenue between 34th and 35th Streets, the site of fashionable homes. Heacock was Bridgeport's first politician, too. He organized the Cook County courts system and then brought the first lawsuit in its courts. (Sketch by Alex Beaubien, courtesy of Chicago History Museum.)

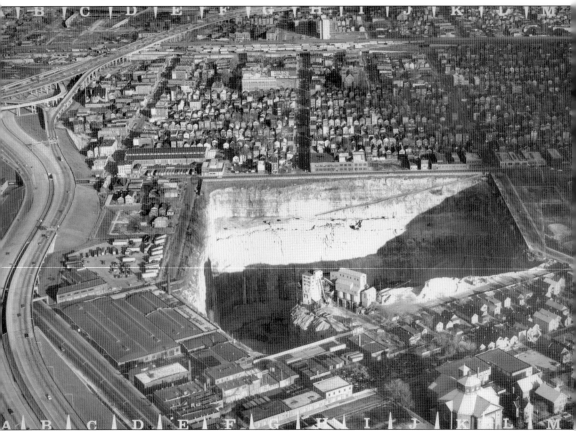

For 140 years, a quarry thrived in Bridgeport. It stretched from 27th to 29th Streets on Halsted Street and down 39th Street to Poplar Street. Industry dug a 17-acre, 400-foot-deep hole. The quarry began in 1830 because stone was needed for shoring Chicago's harbor and building stone walls for the canal. In 1851, Marcus Stearns bought the quarry. It has been Stearns' Quarry ever since. Most Chicagoans remained unmindful, but the quarry's neighbors paid attention. At 1:30 p.m., a daily dynamite blast shook rock from quarry walls and rocked nearby buildings like an earthquake. In 1970, Chicago bought the site to use as a dump—some claim an illegal one. With ash bellowing from its depths, it was named a Superfund site by the Environmental Protection Agency (EPA) by 1997. In 2004, the dump closed. Today, Stearns' Quarry has metamorphosed into beautiful Palmisano Park. (Courtesy of Chicago Public Library.)

Two

"WHAT SIDE YOU FROM?"

Bridgeport's edges have been bent and buckled over time by railroads, expressways, redistricting, media mistakes, and perceptions. ("Why would you include that part?" someone said. "They beat up a guy there; that's why people think we're racists.") Neutral ground is defined from the inside out. Anyone who lives in Bridgeport—regardless of ethnicity or location—belongs. Everyone else does not.

Its places of worship—Protestant, Catholic, and Buddhist—have no physical boundaries. For most, culture, not address, dictates the congregation.

When unacquainted folks from Bridgeport meet, there is a special greeting. In the rest of Chicago, people ask one another, "What's your parish?" Bridgeport residents demand to know: "What side you from?" This is a difficult query at best, especially if the questioner's "side" is unknown to the person being questioned. Is the person from east or west of Halsted (the most important of questions); east or west of the Canal Street (Armour Square territory); east or west of Morgan Street (Lithuanian or Pole); north or south of 31st Street; north or south of 35th Street? The follow-up question becomes "who do you know?" There must be someone in common—perhaps a shared cousin, a friend of a cousin, a high school friend, an amateur ball–team player, or a local tavern. With this resolved, the participants can chat or discreetly leave.

The old Bridgeport private clubs remain: the Old Neighborhood Italian American Club ("ONIAC") on 30th Street and Shields Avenue, St. Joseph's Club on 28th Street and Union Avenue, the Hamburg Athletic Club at 36th Street and Emerald Avenue, and St. Adalbert's Knights of Columbus at 24th and Green Streets.

As ever, Bridgeport's ethnic mix is dynamic. It is one of the city's most diverse neighborhoods, with Asian and Hispanic residents and a good mix of Poles, Lithuanians, Italians, Croatians, Native Americans, descendants of the Pilgrims, and, notwithstanding news reports, African Americans. Curiously, taverns and schools are accessible to all; nationality and "side" do not matter. With Bridgeport bona fides assured, a person is home free.

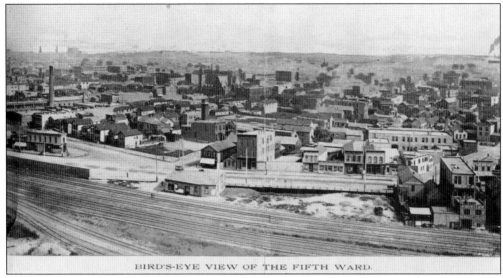

BIRD'S-EYE VIEW OF THE FIFTH WARD.

This picture offers a wide view of the Fourth and Fifth Wards, in which parts of Bridgeport were included, in 1895. The view looks at Bridgeport as if one is standing in the lumberyards of Pilsen, overlooking the vast rail yards south to the Union Stockyards. One can see 22nd Street, its strangely shaped buildings, All Saints Church, and Mark Sheridan School. (Courtesy of Ellen Skerrett.)

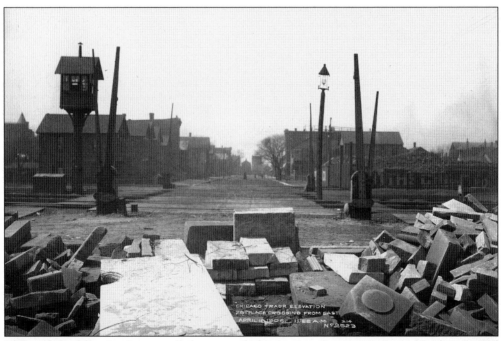

This and the following images tell the story of why Armour Square is a part of Bridgeport and always has been. They explain why it could also be considered a separate area. *The Encyclopedia of Chicago*, for example, calls Armour Square a "leftover community." Built in 1905–1907, the railroad viaduct facilitated flow on Chicago's massive rail yards. What a map-reader may view as a solid line, the neighborhood never did. Ask anyone from Armour Square, and they will say that they are from both Bridgeport and Armour Square. (Courtesy of Chicago History Museum.)

This is the half-built viaduct, easily traversed by neighborhood people. It also demonstrates the beginning of construction of the long viaducts, stretching the length of Bridgeport along Canal Street on the west and Stewart Street on the east with a width of more than a block between the streets. (Courtesy of Chicago History Museum.)

This image shows a completed section of the viaduct on 28th Street. Because of the length and width of the rail yards and viaducts, several churches were displaced. St. John Nepomucene, St. Anthony, and Trinity Lutheran Church were forced to relocate. They set up to move west of the railroads in Bridgeport and rebuild their parishes. (Courtesy of Chicago History Museum.)

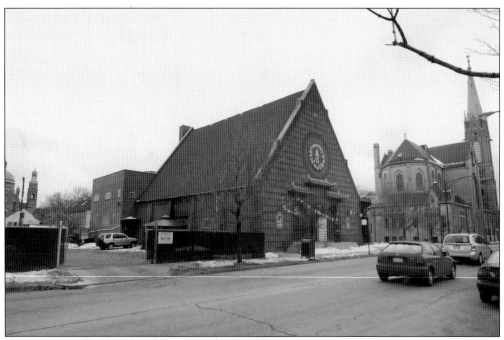

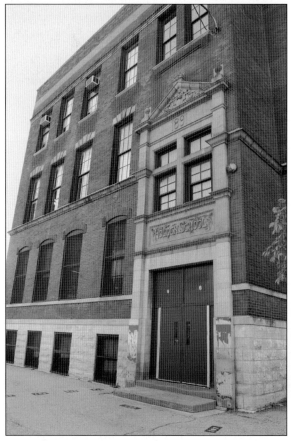

One click of a camera captures the Bridgeport greeting: "What side you from?" This view shows the proximity of a Buddhist temple (center), the towering dome of St. Mary of Perpetual Help (left), and the Benedictine Monastery of the Holy Cross (right). A glance one block left would view the Central Assembly of God church; in the other direction is Holy Cross Lutheran Church. People who pray at these places do not necessarily live near them; that is why their "side" reveals much more than their religious denomination. (Courtesy of Marek Dobrzycki.)

The James Ward Elementary School, erected in 1874, is the oldest public school operating in both the Chicago and Illinois school systems. It started on Garibaldi Street (now Shields Avenue) and was named after a member of the board of education. (Courtesy of Marek Dobrzycki.)

McClellan School, named for Civil War general George B. McClellan, was built in 1881 as the Wallace Street School. In 1885, an addition was made to the school to accommodate the growing population in the southeast quarter of Bridgeport. (Courtesy of Marek Dobrzycki.)

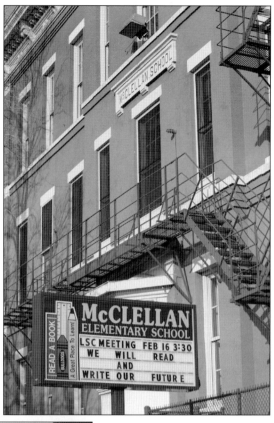

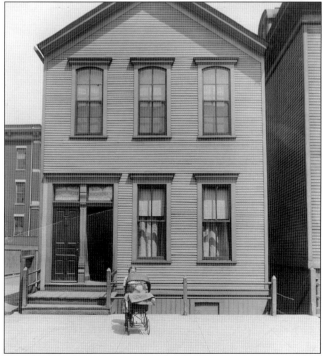

Mark Sheridan School, at 27th and Wallace Streets, grew in three stages. The first school, a small wooden structure, was built in 1874 on 26th Street. The second Mark Sheridan School (pictured here) was a larger wooden building a block down from the old school, at 27th and Wallace Streets. As the population east of Halsted Street grew, Mark Sheridan was again rebuilt, this time on the site of the second school (see next photograph). (Courtesy of Chicago History Museum.)

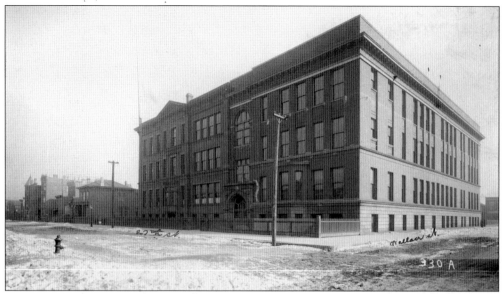

This is the present Mark Sheridan School, named for the Irish-born, four-term alderman who was prominent in his opposition to blue laws, especially those that prohibited a working man from a beer on his day off. Perhaps inspired by Sheridan, the students of Mark Sheridan School boldly walked out of school in 1886 "on strike" in sympathy with their parents and the Haymarket protesters. They were quickly returned to classes. (Courtesy of Chicago History Museum.)

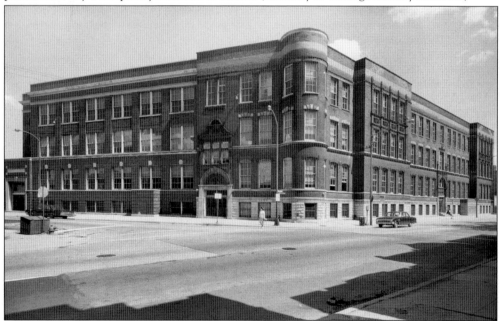

Called at first the Bridgeport School when established on Archer Avenue in 1867, it later gained the name of Charles Holden, the president of the Chicago School Board. Archer Avenue proved a poor place for education. In 1875, the Holden School teachers complained to the city council of the "wild Texas cattle" running down the street during school hours and endangering students' lives. Eventually, Holden School moved to a quieter spot on Loomis Street, then in 1930 to its present location on 31st Street. (Courtesy of Chicago History Museum.)

Most of the Catholic and Lutheran churches in Bridgeport had grammar schools attached to their parishes. SS. Anthony of Padua, Barbara's, and Mary of Perpetual Help also, at one time, included high schools. Both SS. Anthony and Barbara's have closed their high schools. This is a picture of St. Mary of Perpetual Help High School, taken in the 1930s. The school recently closed, then merged with Lourdes High School (an all-girls school farther west), and is now the girls' division of De La Salle High School for Boys. (Courtesy of Chicago History Museum.)

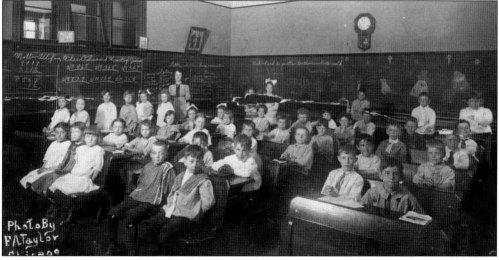

Before the new church was built, Nativity of Our Lord School was started in 1874 in a rented space. This was the usual process in the building of Bridgeport parishes, that the school was organized before the building of a permanent church. (Courtesy of Nativity of Our Lord Church.)

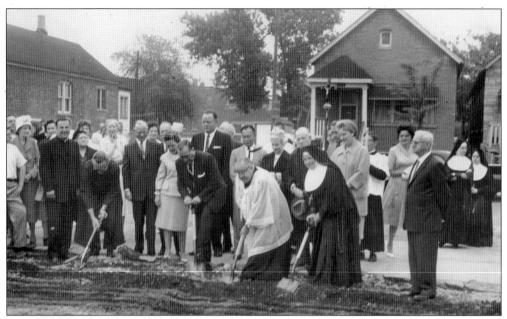

The year 1960 brought the building of a new school at 37th Street and Lowe Avenue for the Nativity Parish. Pictured at the celebration of the new school are faithful parishioners Eleanor "Sis" Daley, standing next to her husband, Mayor Richard J. Daley (wielding a shovel in the middle of the group) and Fr. Michael Conway, beside Mayor Daley and also symbolically turning the dirt for the new school. (Courtesy of Nativity of Our Lord Church.)

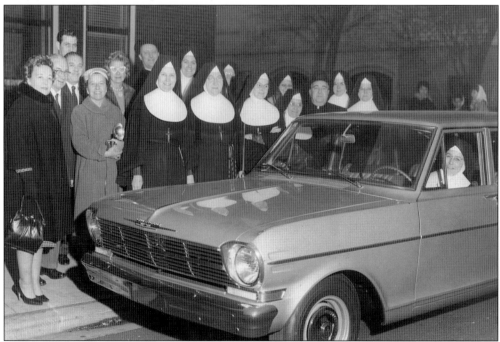

Eleanor "Sis" Daley (Mayor Richard J Daley's wife), the Sisters of St. Joseph of Carondolet, and others celebrate the new car that local merchant M.C. Gersh donated to the Sisters in 1961. (Courtesy of Nativity of Our Lord Church.)

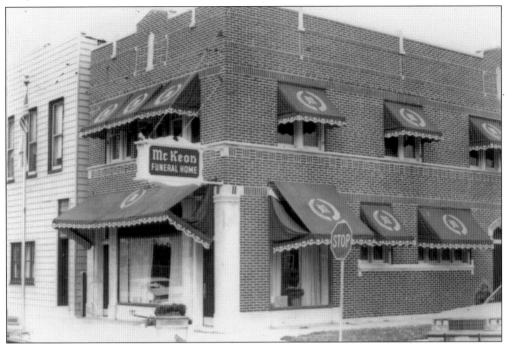

Frank McKeon, born in Ireland but anchored in Bridgeport, founded the McKeon funeral business in 1864. The Union army initially commissioned him to build coffins for Civil War casualties arriving at Union Station in boxcars, preserved in straw and ice. McKeon's first location was on 37th Street, west of Halsted Street, in a stable that was also the home of Nativity Church. In 1880, McKeon moved to 37th and Wallace Streets. By 1928, E. Loretta, Frank's daughter, built the current McKeon Funeral Home at 37th Street and Lowe Avenue. (Courtesy of Chicago History Museum.)

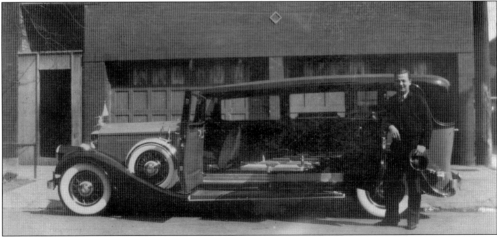

Roman Pomierski opened his funeral parlor on 1917 on West 32nd Street, a block west of St. Mary of Perpetual Help Church, serving Bridgeport's Polania, or Polish community. He died shortly after World War I, and his brother Walter continued the business. Walter's family— Walter Pomierski Jr., his daughter Felice, and son Thaddeus—now operate the funeral home. This 1930 picture is of Walter Pomierski Sr. with a new hearse. The beautiful interior of Pomierski's has been the setting for several television shows and movies. (Courtesy of Felice Pomierski.)

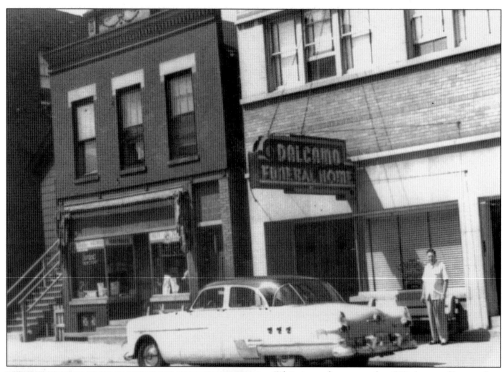

This is a photograph of Dalcamo Funeral Home on 22nd Street, just to the east of Normal Avenue, in 1950. At this time, this part of the neighborhood was mostly Italian American. As the population shifted, the Dalcamos adapted. The big sign now reads both in English and Chinese to accommodate the burgeoning Chinese population. (Courtesy of Charles DiCaro.)

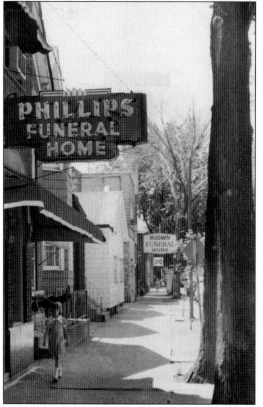

Located on 34th Street, one block west of Halsted Street, were the Phillips Funeral Home and the Rudmin Funeral Home. Both were independently owned. They catered to a German Lutheran as well as Polish and Lithuanian Catholic clientele. This photograph, taken in the 1970s, shows them in operation, although both are now closed. (Courtesy of Charles DiCaro.)

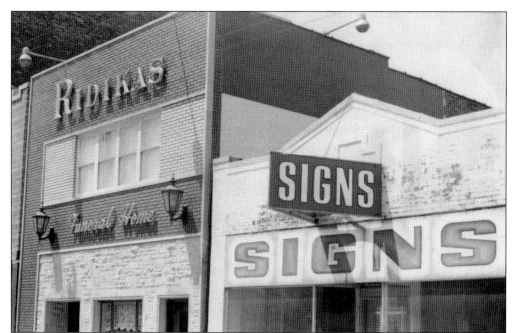

The Ridikas Funeral Home served primarily the Lithuanian community and members of St. George Parish. Located at 3354 South Halsted Street since 1936, it ceased to operate shortly after the Chicago Catholic Archdiocese closed St. George Parish. Jones Sign Co., however, remains in business. (Courtesy of Thomas Egan Sr.)

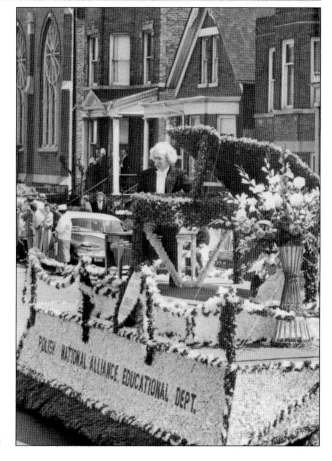

In the early 1960s, Chicago's Polish National Alliance honored Ignacy Jan Paderewski, the world-famous pianist, Polish diplomat, and second prime minister of the Republic of Poland, with a grand float in a parade in Bridgeport. This image of a celebration of Paderewski as a pianist comes from a book called *Nelson Algren's Chicago* and was taken by Algren's friend Art Shay. (Courtesy of Art Shay.)

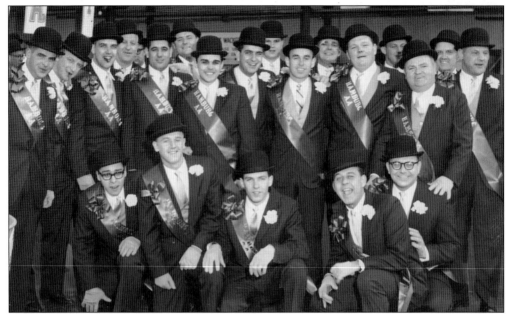

In a series of discreet, attached bungalows, blending into the surrounding homes on 35th Street and Emerald Avenue, stands the Hamburg Athletic Association. Licensed in 1904, it is the oldest licensed association of any kind in Illinois. Its most prominent member and former president was the late mayor Richard J. Daley. The Hamburg Athletic Club is an exclusive men's club. (Courtesy of Hamburg Athletic Association.)

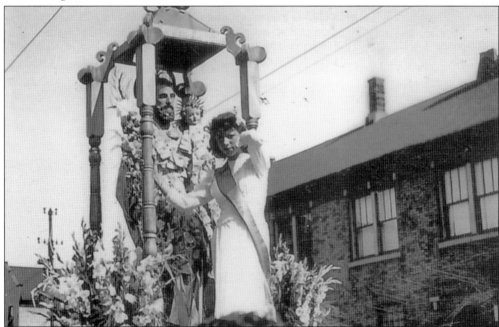

All Saints Church, founded as the third Irish parish in Bridgeport in 1875 on 25th and Wallace Streets, gradually became an Italian parish. St. Joseph's Club, associated with the old All Saints Parish, holds a parade in honor of St. Joseph each year and crowns a queen. In August 1950, the queen chosen was Rosemarie Castellano. (Courtesy of Charles DiCaro.)

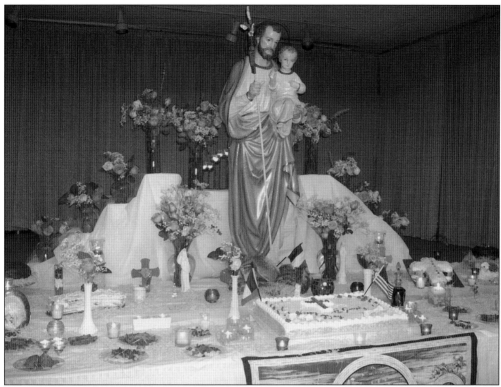

St. Joseph is Sicily's most important saint. During the Middle Ages, the island experienced an extreme drought. People prayed to God, promising that if rain came and saved them and their crops, a special feast honoring God and St. Joseph would be held each year. On March 19, this tradition, St. Joseph's Day Table, is carried on in Bridgeport, among other places, at St. Joseph's Club, where an abundance of food for all is offered. (Courtesy of Sue Friscia.)

In the 1950s, an exclusive girls' club, the DaMoJets, hung around on Princeton Avenue. Admittance was limited; to become a member, one had to live in the neighborhood and be a girl of either Italian or Croatian descent. The club's name combined the nicknames for both nationalities: In Bridgeport, Croatians were called "Mojis," Croatian for "me" or "mine"; Italians were often referred to as "Dagos." On special occasions, the DaMoJets wore matching green sweaters with the club's name adorning the front. (Courtesy of Sue Friscia.)

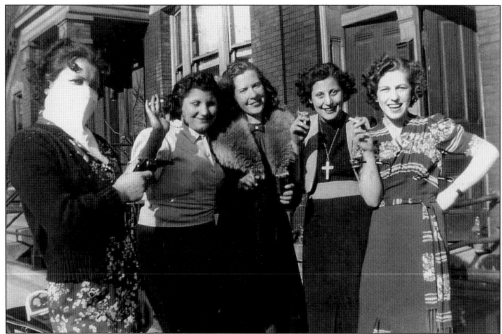

Clowning around are some girls from the Socialites Club, an association for young adults sponsored by All Saints Church. Started in the 1930s, the club numbered over 100 members of both sexes and of all nationalities and Bridgeport parishes. It was famous for its social events, like dances held at prestigious South Side hotels, such as the Shoreland, and picnics on the lake. Its spiritual advisor was Father Mei, a priest from All Saints. (Courtesy of Irene Gazarek.)

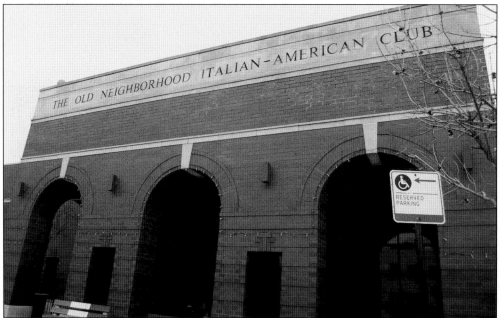

A large, new brick building at 30th Street and Shields Avenue is the new home of the Old Neighborhood Italian American Club, just four blocks north of White Sox Park. The ONIAC club is another exclusively men's club. (Courtesy of Marek Dobrzycki.)

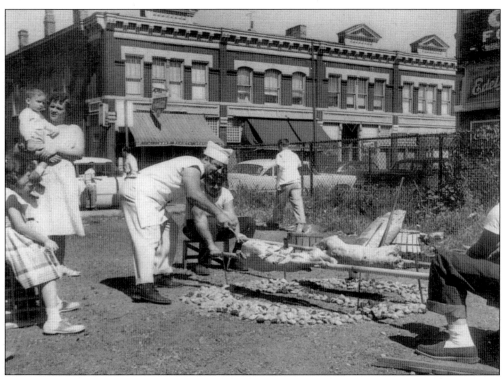

It is not uncommon to see and smell pig or lamb roasts around Bridgeport. This pig roast occurred in the early 1950s at what is now the Ricobene's Restaurant parking lot at 26th Street and Princeton Avenue. The ONIAC club began in one of the row houses across the street. (Courtesy of Ricobene's Restaurant.)

The St. Barbara and St. Mary of Perpetual Help Churches formed the Archbishop Quigley Council of the Knights of Columbus in the 1920s. During the 1950s and 1960s, it headquartered near 31st and Morgan Streets in the redbrick building designed by Chicago architects Burnham and Root and constructed as a church for Polish Presbyterians in 1892. The structure later served as a gym for Benton House and is now a Buddhist temple. (Courtesy of Chicago History Museum.)

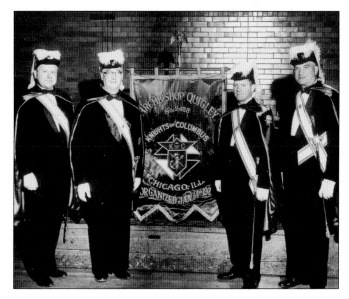

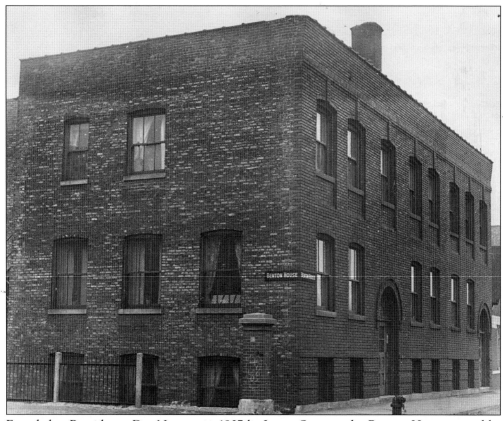

Founded as Providence Day Nursery in 1907 by Janett Sturges, the Benton House started by offering day-care support for mothers who worked in local factories. The nursery provided the children with three meals a day and weekly health checkups by a local doctor. For the parents, it held nutrition clinics and English classes in the evening. (Courtesy of Benton House.)

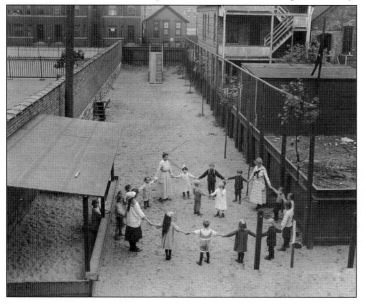

In 1910, a group of Benton House nursery school children plays ring-around-the-rosy in the nursery's backyard at 3052 South Gratten Avenue. Notice how deep the backyard looks; the street behind it has just been raised to meet the city's uniform height standards. (Courtesy of Benton House.)

At 33rd Street and Emerald Avenue, Valentine Chicago Boys' Club, built in 1938 at the behest of wealthy furniture manufacturer L.L. Valentine, provides space for all sorts of activities for neighborhood children. This two-story building has basketball courts, a swimming pool, gyms, and auditorium. The front doors are flanked by two five-ton, 45-foot red cedar totem poles, carved by Ernest Gebert. The club is now for boys and girls. (Courtesy of Chicago History Museum.)

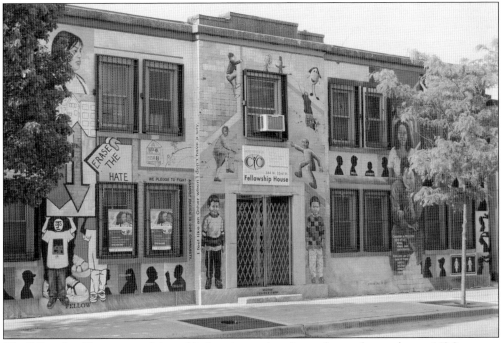

The Fellowship House, part of the public housing project, is another settlement house. US Secretary of the Interior Harold Ickes and Chicago's Mayor Ed Kelly had these homes, called Bridgeport Homes, built for returning veterans in 1946. (Courtesy of Marek Dobrzycki.)

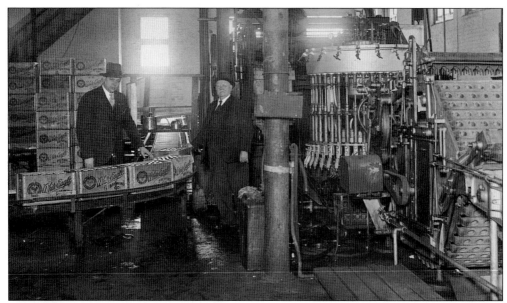

The White Eagle Brewery, founded in 1907, was designed by John Flizikowski, a noted Polish architect of Cassubian heritage. The brewery was located at 3755 South Racine Avenue. As can be deduced by its name, the White Eagle served a Polish clientele. The brewery allegedly stopped making beer during Prohibition but publicly reconstituted the business in 1933. It ceased operation in 1950. (Courtesy of Polish Museum of America.)

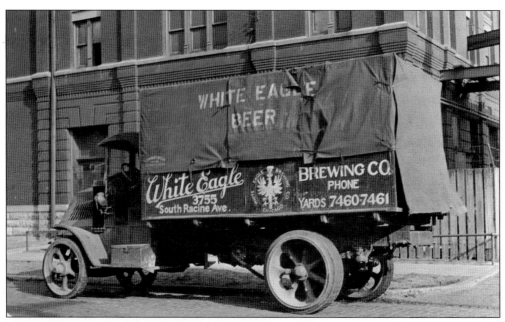

This is a White Eagle truck parked in front of the brewery filling up with one of its many brands—Allweiden beer, Chevalier beer, Allweiser beer, and Our Pride pilsner beer. Notice the Polish eagle, the symbol of the brewery and of Poland, emblazoned on the side of the truck. (Courtesy of Polish Museum of America.)

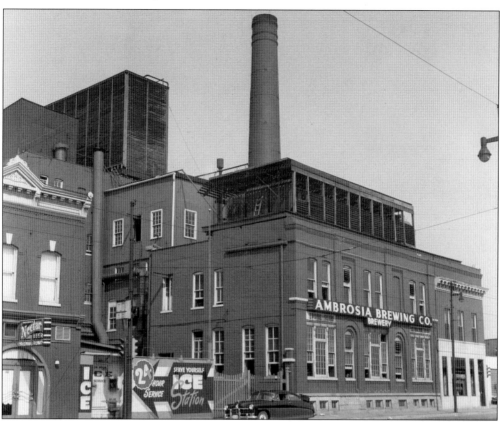

Southside Brewing Company opened in 1874 and allegedly closed because of Prohibition in 1920. It reopened in 1933 and changed its name in 1938 to Ambrosia after its most famous beer (Nectar was another of its brands). It closed in 1959. Here, in 1936, a truck sits in front of Schaller's Pump, a saloon at 37th and Halsted Streets across from the 11th Ward Regular Democratic Organization. (Courtesy of Chicago History Museum.)

Mr. and Mrs. Harvey Schaller opened their restaurant and tavern in 1881 in the then mostly German Hamburg section of Bridgeport. Presently, it holds the oldest restaurant and liquor licenses in Chicago. Back when the Southside Ambrosia brewery was in operation, the brewery buildings surrounded the Pump. The name "pump" derives from the use of a direct pumping line from the brewery into the tavern, similar to a modern-day brewpub. (Courtesy of Schaller's Pump.)

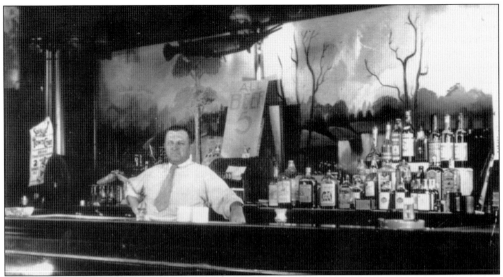

Gazarek's Tavern on the corner of 29th Street and Union Avenue served Bohemian fare: roast pork sandwiches, dumplings (cooked by Frances and daughter Julia), and Yusay Pilsen beer (served by Mike and their five sons). It thrived from 1925 through 1955. Mike's business cards read, "Not the largest, but the best; tables for ladies." Here, Mike stands behind the bar in 1930. When asked if he sold alcohol during Prohibition, he replied, "I didn't have to sell it, I just had to buy it." (Courtesy of Gerry Poplar.)

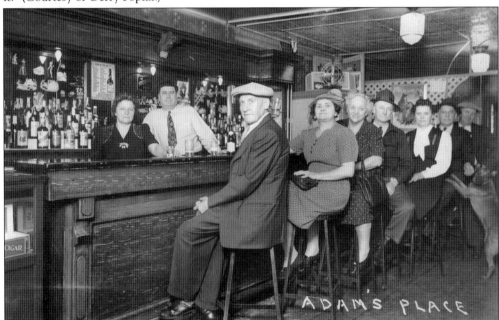

A Lithuanian bar, Adam's Place was located at 32nd and Halsted Streets. Adam Dauksha was the proprietor and owner of several buildings along the "Lithuanian Downtown" strip of Halsted Street. John Badauskas worked for Adam, and in 1965, John and his wife, Bernice, bought the bar and changed the name to John and Bernice's Tavern. Now run by Bernice and her sons Steve and Mike, it is a popular hangout for local artists and blue-collar workers alike. (Courtesy of Steve Badauskas.)

Since the 1920s, the Gem Bar stood at Loomis and Eleanor Streets, next to the I&M Canal and the bridge over into Pilsen. Polish immigrant Joseph Gembara opened it to feed canal workers and sell them hooch out his back door. His son Eugene "Herman" Gembara, a bridge tender, water reclamation engineer, and Democratic precinct captain, helped run the tavern. This is a picture from the 1940s of an unidentified friend (left), Joseph (center), and Herman in front of the tavern. It stands on the former Leigh's Place property. (Courtesy of Barb Kopec.)

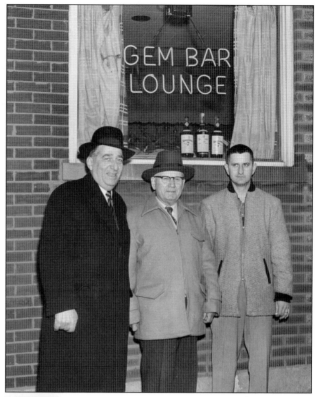

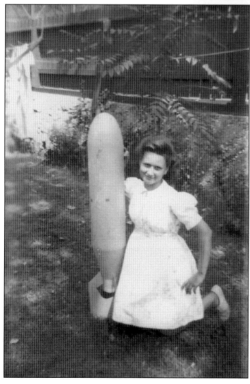

Holding a war souvenir, Andzia Gembara, Herman's daughter, strikes a cute pose in the backyard of the Gem Bar in 1944. Luckily, it did not explode. (Courtesy of Barb Kopec.)

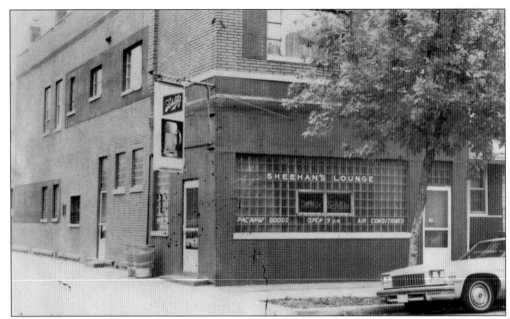

Sheehan's Tavern in the 1970s operated on 38th Street and Union Avenue, kitty-corner from the well-known and still operating Shinnick's Tavern. Dan Sheehan, who was famous for dressing completely in green on St. Patrick's Day, owned it. Sheehan's was also very popular for its bartender Lefty Hughes, who was listed in the *Bartender's Guide to Chicago*. (Courtesy of Kelly Hughes.)

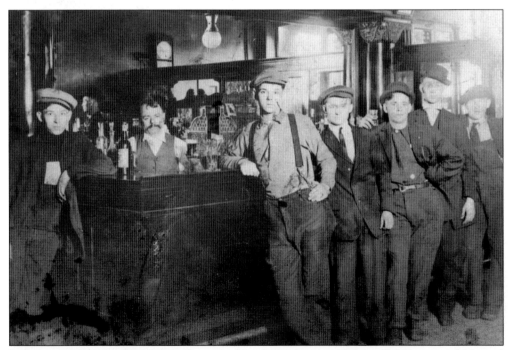

Italian immigrant Joseph Naponiello opened his first saloon in 1918 on 25th Street and Normal Avenue. The profession of bartending and bar owning was passed down in the family. (Courtesy of Joseph Naponiello.)

Naponiello's Cocktail Lounge and Bowl opened March 30, 1950. It was run by brothers Nick and Joe, descendants of the original Joseph Naponiello. The bowling alley drew fans from all sections of Bridgeport. The cocktail lounge was honored for its elegance and hand-painted walls. (Courtesy of Joseph Naponiello.)

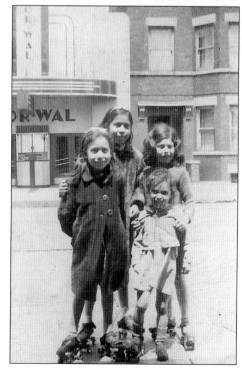

The Norwal movie theater between Wallace Street and Normal Avenue on 26th Street attracted moviegoers in the 1940s and 1950s. Before that, it was known as the Butler Theater, which opened in 1913. It stood next to Naponiello Lounge and Bowl and was owned by the Naponiello family. In this picture, the Chiara sisters wait to go into a show in 1950. (Courtesy of Anthony Chira.)

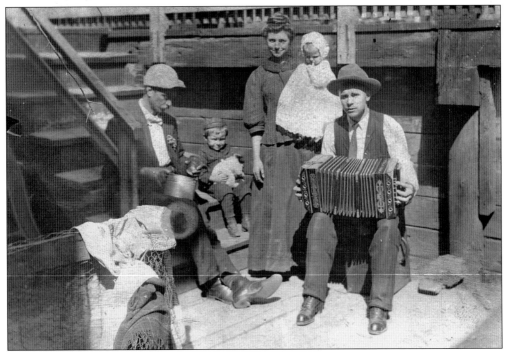

This is an unidentified *famiglia*, or family, of pre-1900 Italian immigrants to the Chinatown section of Bridgeport. The original address is listed as 3138 Spring Street (now 26th Street and Normal Avenue). (Courtesy of Chicago History Museum.)

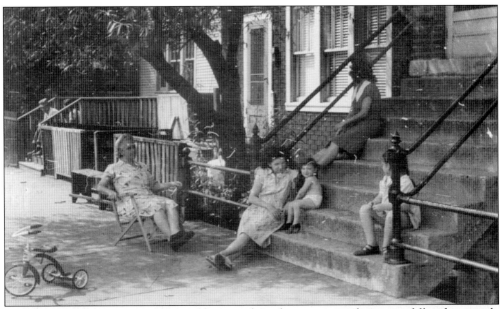

In the spring (when it was warm enough), certainly in the summer, and on warm fall nights, people in Bridgeport stoop-sit (as do folks in other neighborhoods like Taylor Street). Always in the front of the house (never in the backyard), neighbors chat, exchange news, and probably prevent crime. Many used lawn chairs, instead of stoops, for comfort. (Courtesy of Charles DiCaro.)

At 38th and Wallace Streets in the Hamburg side of town in 1946, Catherine Giblin stands on her side porch, with the prairie behind her. The lot to the south of this gangway was full of cinders and still had a hitching post for a horse until the 1970s, when a modern home was built on the property. This home is owned by Maureen Sullivan, Catherine's daughter and coauthor of this book. (Courtesy of Maureen Sullivan.)

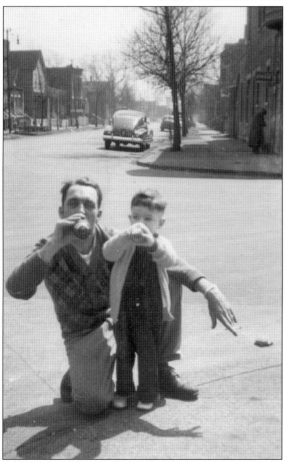

Father and son John and Dan Sullivan enjoy a pop on the corner of 36th and Parnell Streets in 1948. They are the father and eldest brother of author Maureen Sullivan. (Courtesy of Maureen Sullivan.)

For over 100 years, the Bucket of Blood (officially, the New National Auditorium) at 33rd and Morgan Streets hosted Bridgeport weddings, dances, and celebrations, regardless of nationality or "side." The nickname "Bucket of Blood" is an inside neighborhood joke: the festivities more often than not ended in donnybrooks. This is the old bandstand, now tucked into a corner of what was the ballroom. Lawrence and Anna Zalesiak owned the place until it closed around 1970. (Courtesy of Prof. Giedrius Subacius.)

The Zhou Brothers, internationally renowned Chinese-born artists, bought the old Bucket of Blood dance hall in the 1990s. Down Morgan Street, at 35th Street, they now operate the Zhou B Art Center, with studios, galleries and cafés, but they actually live in the Bucket of Blood. They redesigned it to reflect their art and Chinese heritage but with an eye to the history of the neighborhood; it is also homage to community history. The Zhous' living room contains the old polished walnut bar, and the 1900 traditional tin ceiling still sparkles above. Down the long entry hall, the Zhous have created collages of Chinese symbols intermixed with Polish sheet music (from the Gralak Music Store) they found about the dance floor when they first purchased the building. (Courtesy of Erin McClellan Zhoushi.)

40

Three

SPIRES AND DOMES

When a person looks toward Bridgeport from the Stevenson Expressway, the skyline holds a vista of spires and domes. They reflect the jumble of nationalities that have called this neighborhood home: Irish, German, Bohemian, Polish, Lithuanian, French Canadian, Italian, Croatian, Mexican, and Chinese. Before 1990, there were even more spires and domes; that year, the Chicago Catholic Archdiocese closed six churches, with most falling victim to the wrecking ball. Although predominantly Catholic, Bridgeport's religious variations surprisingly include the following: Lutheran (three existing German churches and at one time Lithuanian, Norwegian, and Swedish parishes); American, Lithuanian, and Chinese Baptists; long-gone Presbyterians (Poles and Germans); a Church of God; breakaway Polish and Lithuanian National Catholic groups; Congregationalists; and even a synagogue. Religious diversity continues to increase today, as continued Chinese migration into Bridgeport has seen the rise of a vibrant Buddhist community. The design of these sacred spaces ranges wildly in scale, from simple bungalows to towering edifices proclaiming God's grandeur. It is important to keep in mind that ethnicity, not proximity, dictates parish population. An Italian might find a German parish of his same confession right outside his door, but he will travel to the other end of Bridgeport to go to Mass with his paisans.

The history of these houses of worship traces the history of the settlement of the neighborhood; an ethnic group arrives, and a congregation from outside the area sponsors a mission for the newcomers. The new congregation grows, builds a school, then finally a church (sometimes a two-story affair, with the church on the ground floor and school above). Some congregations follow their community to another city neighborhood, like the Swedes moving to Englewood and the French Canadians farther south. Some still thrive, celebrating centennials and beyond. Others blend ethnicities. Several churches hold Mass and confession in Polish and Spanish, with shrines honoring both Our Lady of Czestochowa and Our Lady of Guadalupe. The German St. Anthony of Padua became the Italian/Mexican All Saints/St. Anthony church. With a temple for every nation in this petite patch of God's good earth, there is little wonder that Bridgeport would be highlighted in the *The Spiritual Traveler: Chicago and Illinois: A Guide to Sacred Sites and Peaceful Places*.

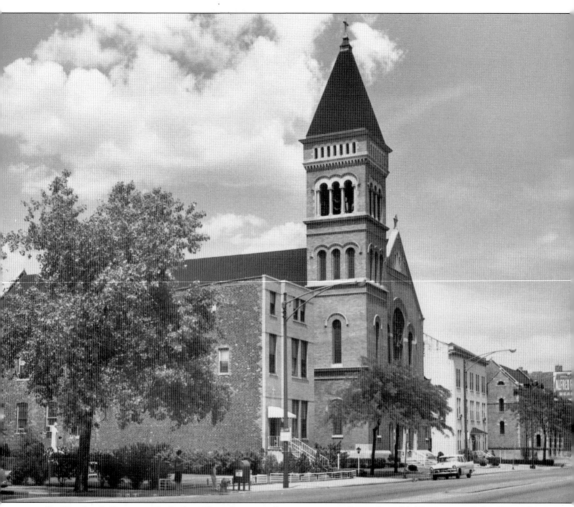

St. Bridget's Roman Catholic Church started as a mission from the old (downtown) St. Patrick's Church for Irish workers living along the beginnings of the Illinois & Michigan Canal. The mission opened in 1850; the parish church finally was built in 1862 on the corner of Ach Street and Archer Avenue. Mayor Ed Kelly and the Guilfoyles (Eleanor "Sis" Guilfoyle Daley's family) were among the more prominent parishioners. In the 1960s, the church acquired the nickname "Our Lady of the Highway." In 1990, St. Bridget's was torn down along with several other Catholic churches. (Courtesy of Chicago History Museum.)

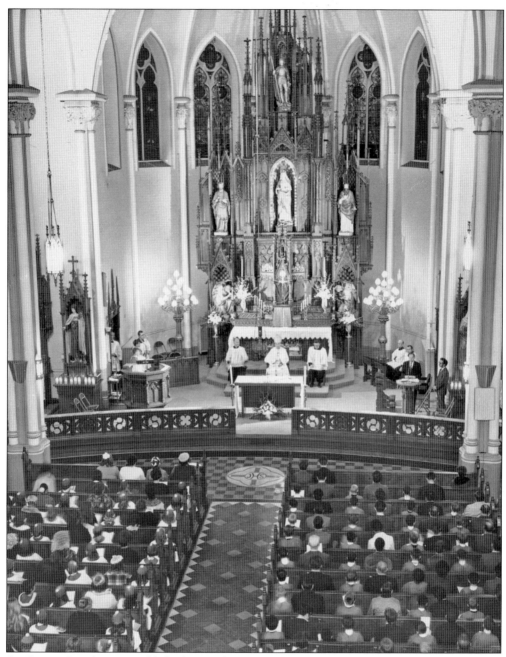

St. George Parish was established at 33rd Street and Lituanica Avenue (once called "Auburn Street"). It was one of the first Lithuanian Catholic communities in America. The congregation initially operated out of an old wooden German church across the street. The parish, as was the custom, first built a school and rectory; finally, in 1896, it erected this Neo-Gothic church. As the Lithuanian residents moved farther south to Marquette Park, the congregation diminished. The church was closed and torn down in 1990. (Courtesy of Grazina "Gina" Biciunas-Santoski.)

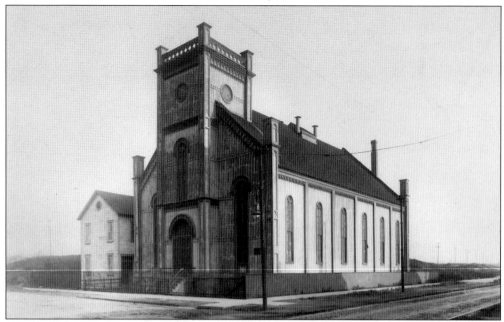

First Lutheran Church of the Trinity was founded in 1865 as the first Lutheran church on Chicago's Near South Side. It is the third-oldest "daughter" of First Immanuel Lutheran Church (1124 South Ashland Avenue), established in 1854, and "granddaughter" of First St. Paul's Evangelical Lutheran Church (1301 North LaSalle Drive), established in 1847. The current First Lutheran Church of the Trinity started out as a German immigrant parish named Evangelische Lutherisch Dreieinigkeit ("Evangelical Lutheran Trinity"), supported an elementary school, and earned the nickname "Mother Church of the South Side" for numerous branch schools that eventually developed into daughter congregations on the South Side of Chicago. First Trinity is the oldest Christian congregation in Bridgeport. This photograph depicts the original church located at 25th Place and Canal Street. After the railroad took possession of that property in 1904, the congregation moved to its current location at 31st Street and Lowe Avenue. (Courtesy of First Lutheran Church of the Trinity.)

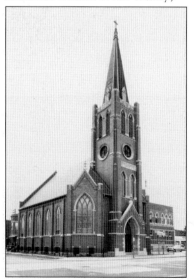

The current First Lutheran Church of the Trinity, at 643 West 31st Street (31st Street and Lowe Avenue), is the oldest Christian congregation in Bridgeport. First Trinity is home to several missionaries, a vibrant congregation, and services for the community such as a clothing pantry, community meals, and concerts. (Courtesy of First Lutheran Church of the Trinity.)

Salem Lutheran Church was founded by Swedish immigrants in the Armour Square section of Bridgeport as one of four Swedish Lutheran parishes in 1868. The church's name in the Swedish language can be seen over the doorway in this image. (Courtesy of Evangelical Lutheran Church in America Archives.)

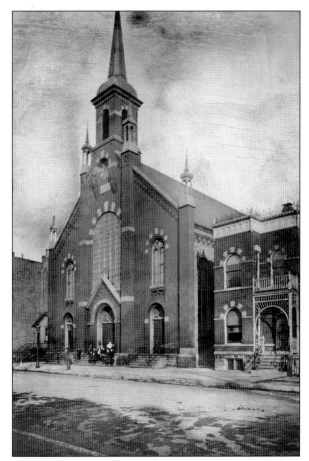

In the early 1900s, the congregation at Salem moved out of Bridgeport, along with most of the Swedish community, to Englewood. Since 1922, this has been the site of St. Jerome's Catholic Church. (Courtesy of Evangelical Lutheran Church in America Archives.)

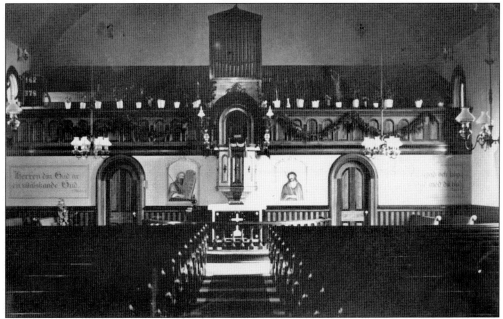

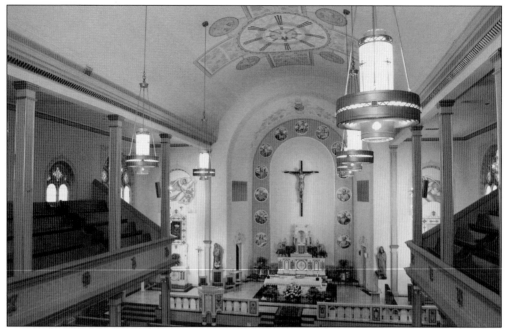

St. Jerome's Roman Catholic parish was established near 25th Street and Wentworth Avenue (Chinatown) in 1912 at the behest of Archbishop Quigley, who sent to Europe for a priest to minister to the growing Croatian community. In 1922, the parish bought the site of the old Swedish Lutheran church at 29th Street and Princeton Avenue. Host to a sanctuary for devotion to Our Lady of Sinj, Princeton Avenue was given the honorary name Cardinal Stepinac Way for the Croatian Catholic cardinal. (Courtesy of St. Jerome's Parish.)

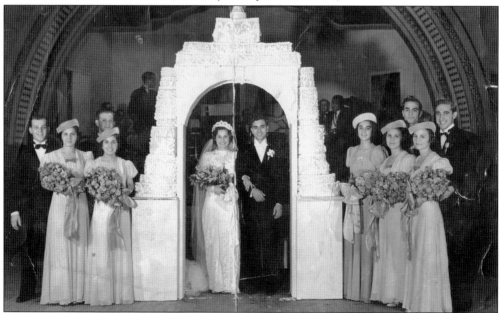

This is the wedding reception of Chester Palumbo in St Jerome's Hall. According to family tradition, the young couple is standing beneath the wedding cake that arches above them. This custom of the wedding cake arch is still kept by the Paulmbo family. (Courtesy of Sue Friscia.)

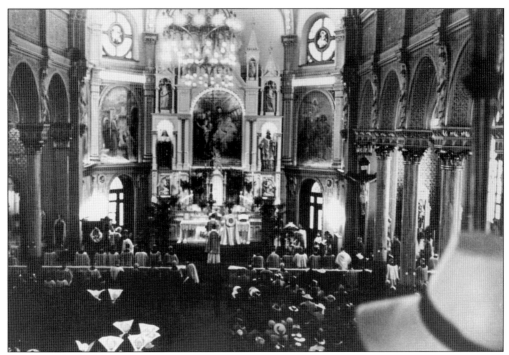

This is the pre–Vatican II interior of the Nativity Of Our Lord Roman Catholic parish at 3700 South Union Avenue. Founded by Irish immigrants in a livery stable on 37th Street just west of Halsted Street in 1863–1864, the parish relocated to its current home in 1879. It is now the oldest operating church in Bridgeport. Notable longtime parishioners include the Daley family, whose members still attend mass here on a regular basis. (Courtesy of Nativity of Our Lord Parish.)

This image shows the modern interior of the Nativity of Our Lord Church at 3700 South Union Avenue. The church was remodeled and simplified in the late 1980s. (Courtesy of Nativity of Our Lord Parish.)

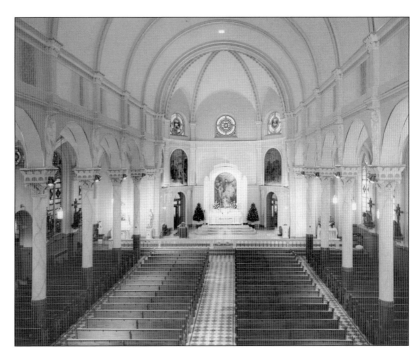

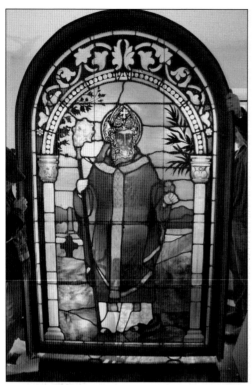

From the high north corner of All Saints Church, this stained glass window—10 feet tall, 5 feet wide, and perhaps 150 years old—depicts the image of St. Patrick and has colors that still dazzle, especially the top of the bishop's crook filled with golden shamrocks. When the church was torn down in the 1970s, Butch McGuire, the owner of a popular North Side nightspot, rescued it. For over 40 years, St. Patrick has stood vigil in the bar's attic. (Courtesy of Bob McGuire and Marek Dobrzycki.)

All Saints Catholic parish was founded by the Irish on 25th and Wallace Streets in 1875. The congregation became increasingly diverse over time; starting in 1927, Mexican immigrants begin to enter the parish rolls. (Courtesy of Charles DiCaro.)

St. Anthony of Padua Parish was established for German Catholics from a mission originated by St. Peter's Church at 24th and Canal Streets, pictured here. Legend has it that during the Great Chicago Fire, the parishioners of St. Peter's prayed to St. Anthony for protection and promised a church in his name. The fire never crossed 22nd Street. In 1913, the railroads paid to move the parish to 28th and Wallace Streets, where it now stands. It remains the only church complex in Bridgeport with an architecturally matching church, school (both grammar and high school), rectory, and convent. (Courtesy of St. Anthony Parish.)

St. Mary of Perpetual Help Parish was organized by Polish Catholics in 1882 at Lyman and Farrell Streets. The current church, with its distinctive copper dome, was built in 1889–1892 by the architect Henry Engelbert. It was consecrated in 1903. It is one of Bridgeport's two "Polish cathedrals"; an identical twin church was constructed in Detroit under the name of St. Casimir. That church was later demolished in 1967. (Courtesy of St. Mary of Perpetual Help Parish.)

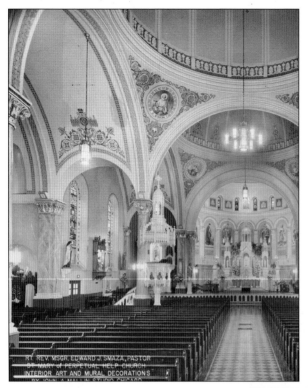

Pictured is the interior view of St. Mary of Perpetual Help. The parish is still thriving with a predominantly Polish and Mexican congregation. Recently, De LaSalle took over the old grammar school building for its all-girls campus replacing, in effect, Lourdes High School from the far southwest side of Chicago. (Courtesy of St. Mary of Perpetual Help Parish.)

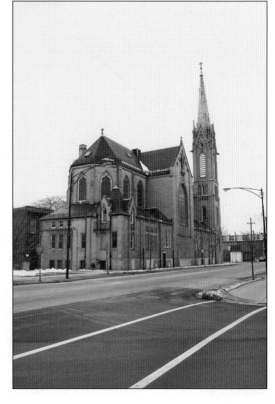

Immaculate Conception Parish at 31st and Aberdeen Streets (originally Mosprat and German Streets) was founded by German Catholics in 1883. The school was built first, followed by the rectory and convent. The church was built in 1909 by architects Hermann J. Gaul and Albert J. Fischer. The parish was closed in 1989 and became the Benedictine Monastery of the Holy Cross in 1991. (Courtesy of Marek Dobrzycki.)

Holy Cross Lutheran Church was founded by Germans in 1886 and is located at 3130 South Racine Avenue. Typical of Chicago's churches, its aesthetic betrays this Lutheran congregation's Teutonic roots. (Courtesy of Louise Pokrant.)

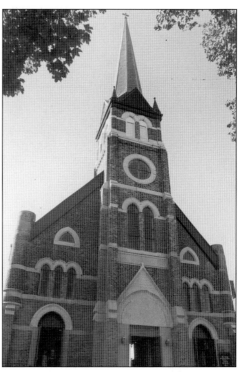

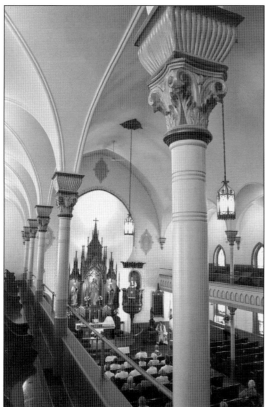

Here is an interior view of Holy Cross Lutheran Church. The balcony, seen here, is typical of Protestant church design, similar to that seen in the former Lutheran Salem Church that is now St. Jerome's Catholic Church. (Courtesy of Louise Pokrant.)

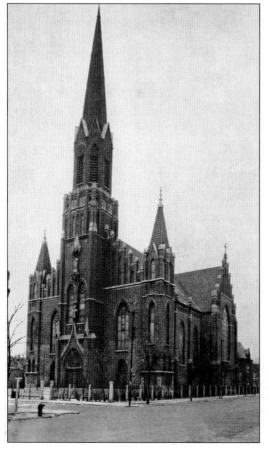

Doremus Congregationalist Church, located on 31st Street and Normal Avenue, started in 1891 as a mission of the Plymouth Congregationalist Church on 28th Street and Princeton Avenue. The original pastor, Doremus Scudder, left to open another mission in Asia. For 50 years, Doremus was led by Reverend Kooger, a native of Holland whose mother's family owned a steelworks at 26th Street and Emerald Avenue. Doremus maintained one of the only basketball gyms in the area, drawing players from many faiths. It has a fireplace from one of the Prairie Avenue mansions and acquired a fountain from the Morse Mansion on 43rd Street and Cottage Grove Avenue in the 1940s. Doremus merged with a nondenominational Christian church in 2002 and is now known as the New Life Community Church. (Courtesy of Marek Dobrzycki.)

This is an exterior shot of St. George Roman Catholic Church, the first Lithuanian Church in Chicago. Its elegant Neo-Gothic styling easily rivaled Bridgeport's two Polish cathedrals, St. Mary of Perpetual Help and St. Barbara. (Courtesy of Grazina "Gina" Biciunas-Santoski.)

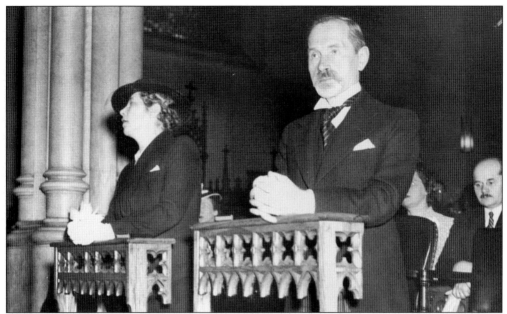

Named for the patron saint of Lithuania and located in the neighborhood that was home to Chicago's Lithuanian Downtown at 35th and Halsted Streets, St. George Church's interior is seen here. Lithuanian president Antanas Smetona is shown attending Mass. After demolition, the church's fixtures were later sent to Lithuania to furnish churches that had seen their interiors looted and destroyed by the Soviet regime during Lithuania's half-century occupation by the Union of Soviet Socialist Republics. (Courtesy of Balzekas Lithuanian Museum.)

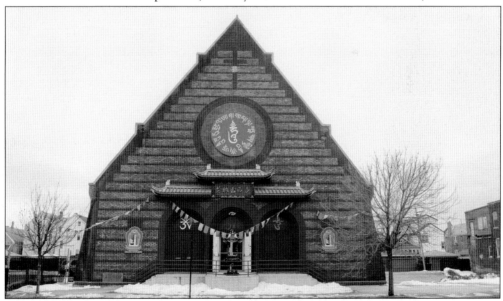

Burnham and Root designed Immanuel Presbyterian Church, located between Gratten Avenue and Bonfield Street on 31st Street, for a primarily Polish congregation. This was the last building constructed before Root's death in 1892. After the Presbyterian church closed in 1930, the building became the Benton House gym and then, in the 1950s, the local Knights of Columbus Hall. In 1994, it became the Lin Shen Ching Tze Temple. (Courtesy of Marek Dobrzycki.)

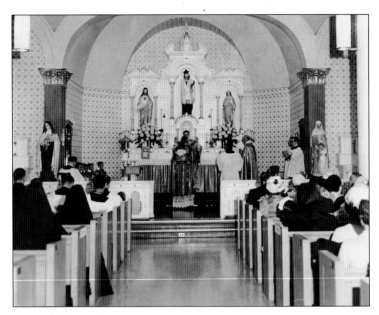

St. John Nepomucene Roman Catholic Church was founded by Czech Catholics near Armour Square. In 1914, the parish moved because of railroad expansion to 2953 South Lowe Avenue. The church closed in 1990; the facilities are now in use by St. John's Special Religious Development (SPRED) as a ministry to the mentally challenged. (Courtesy of Father George Cerny.)

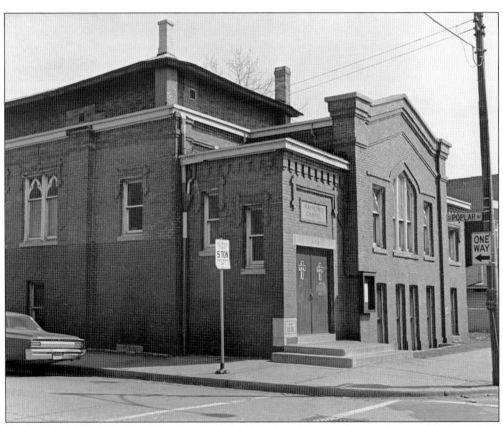

Dating from 1905, Raymond Baptist Chapel, located on the corner of 31st and Poplar Streets, is now an Assembly of God church. (Courtesy of Chicago Historical Society.)

Along with St. Mary of Perpetual Help, St. Barbara was one of three Polish Roman Catholic parishes that began in Bridgeport. Established on 29th and Throop Streets in 1909, this octagonal church with Romanesque stylings was completed in 1914. While the high school closed recently, St. Barbara Parish still serves its predominantly Mexican and Polish congregation. (Courtesy of Marek Dobrzycki.)

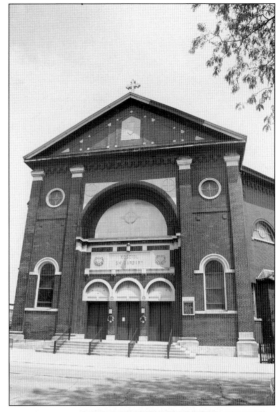

The interior of St. Barbara Church, or "Barbarowo," as the parish's founding Polish community referred to it, highlights the wedding vows of Irene Wichert and Cyril Gazarek in 1946. St. Barbara lived up to its reputation as one of Bridgeport's two Polish cathedrals. Now, it exalts both a Polish and Mexican heritage. (Courtesy of Irene Gazarek.)

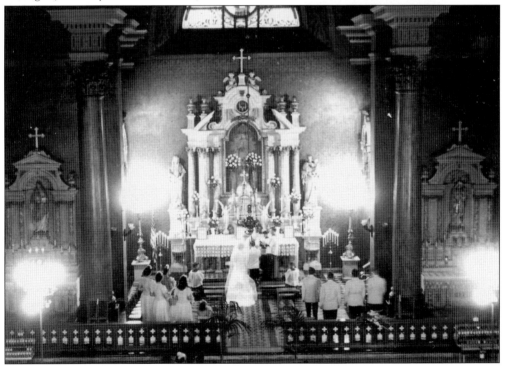

This photograph of an unidentified friend of Casey Pachunas shows one of the only images of Anshe Amuna Synagogue at 3319 South Emerald Avenue. The Anshe Emunah Ladies society at 3321 South Emerald Avenue was located next door. The synagogue operated until the late 1940s. (Courtesy of Casey Pachunas.)

Here is Nick Bertucci (holding a cane) giving a donation to St. Rocco. St. Rocco's fame comes in large part as a healer par excellence, patron saint of the sick. After each donation, the band plays and fireworks go off. (Courtesy of Charles DiCaro.)

Four

HOW BRIDGEPORT TRANSFORMED COMMERCE

Bridgeport's location coupled with its access to transportation was irresistible to industry and commerce, which included farming, fur trading, the canal, quarry, and slaughterhouses, rolling mills, and breweries. Folks flocked to Bridgeport for jobs. A 1910 population of 32,000 grew to over 60,000 by 1920.

In 1833, the Irish veterans of the Erie Canal came to build the Illinois & Michigan Canal—no machinery, just brawn and shovels. They lived along the canal banks and grew vegetable patches called "cabbage gardens." Their "ditch" changed the nation. Trade once routed south down the Mississippi River to New Orleans, through the Gulf of Mexico, and up to New York shifted east through Chicago and reached New York via the Great Lakes and Erie Canal. Bridgeport permanently transformed the flow of American commerce.

In 1830, Robert Healy opened a quarry at 27th and Halsted Streets that operated until 1969. It became known as Stearns' Quarry and provided limestone for the canal, harbors, and houses. Slaughterhouses thrived near the quarry, on Halsted Street, and along the river. Other industries followed: glue works, lumberyards, grocers, undertakers, banks, and saloons.

By 1890, Bridgeport boomed with industrial diversity. Ingenious design exploited its geographic serendipity by creating the first planned and privately owned industrial park: the Central Manufacturing District ("CMD"), the blueprint for industrial strategy nationwide.

Frederick Prince's Railway operated between the stockyards and national railroads. Prince wanted more to ship. In 1892, he purchased 400 acres adjacent to his railway stretching from Bridgeport into McKinley Park. He incorporated the CMD, enrolled civic leaders as trustees, and issued finance bonds.

The CMD offered manufacturers everything: paved streets, utilities (gas, water, electricity), a private club, and its own magazine. A security force policed the area, and a fire company protected it. A. Epstein & Co. became official architects, specifying land use and building design. CMD's bank financed its businesses; only one company ever failed. CMD's real enticement was labor access: 48 percent of Chicagoans lived within four miles.

CMD's manufacturers included Wrigley Gum, Ford, Westinghouse, Spiegel, cooperages, coal companies, and paper, piano, glass, iron, furniture, steel, chemical, beer, biscuit, and sausage makers. The CMD prospered into the 1950s. By then, suburban land became more attractive for flatter, longer buildings and easier access without low viaducts hampering deliveries.

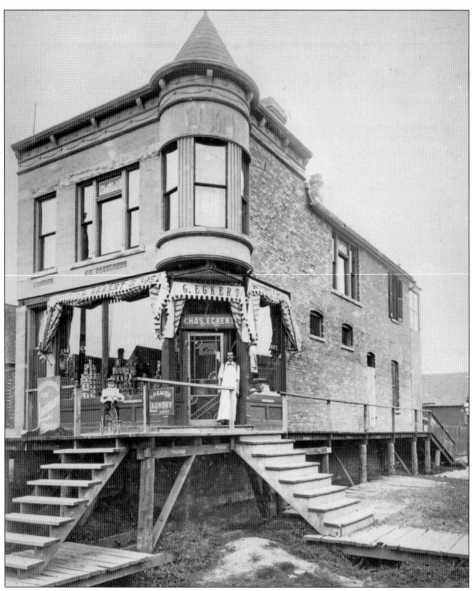

Herr Charles Eckert stands proudly at his Archer Avenue grocery. It is a family store, with Charles's name above the door and his brother George's name on the awning. In the 1880s, Archer Avenue was a good location for a grocery, as Bridgeport's diversified industries brought customers. While Archer Avenue would become a major commercial center, Bridgeport also developed a patchwork of stores in its diverse ethnic enclaves. It is not the store but the height of the business over the street that fascinates in this image, with two levels of wooden sidewalks—the lower over a muddy, unpaved street and the higher, six steps up. Chicago, once called "the City of Ups and Downs," duplicated the Eckert scenario all over town. After all, Chicago sits at lake level, and floods and lingering muddy pools were familiar. In 1854, a typhoid epidemic killed six percent of the population. If the city were to grow, it had to stem the problem. In 1858, it began phasing in a uniform street height; the project was finished in the in the early 1900s. If they could afford it, building owners raised their structures to meet the new street levels. (Courtesy of Chicago History Museum.)

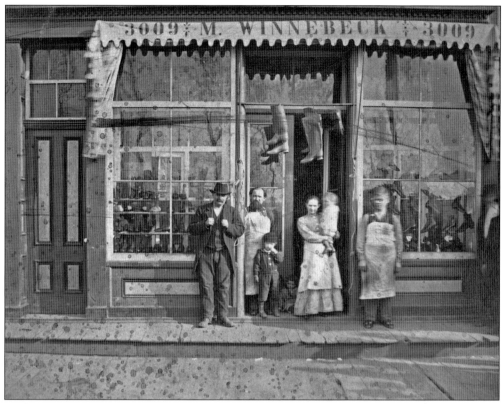

In the 1890s, Phillip Koch Boot Shop, 3100 Archer Avenue, sold cowboy supplies. Boots hang from its doorway, and in the right window, a saddle is for sale. Bridgeport had real cowboys, drovers who herded animals in the streets from canal barges or the railroads to slaughterhouses. (Starting in the 1930s, trucks moved animals directly into the yards.) Even Dick Daley, as a young man, had a summer job as a drover. (Courtesy of Chicago History Museum.)

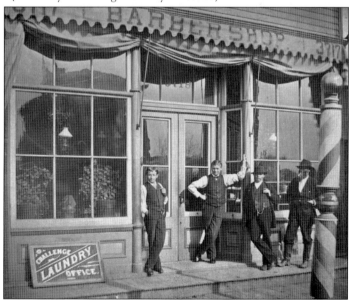

Near Schaller's Pump and the 11th Ward Regular Democratic Organization, this building at 3717 South Halsted Street catered to those in need of a close shave. The striped pole (and the awning) said "this is a barbershop." But like most barbershops of the 1900s, it provided more than a shave and a haircut. One could get his or her shirts washed at the Challenge Laundry. (Courtesy of Chicago History Museum.)

In 1910, Antoni Ostapowicz, a cobbler, operated his shop at 3146 South Morgan Street. The business stood on the west side of Morgan Street, the Polish side. The east side of Morgan Street was Lithuanian. It was unlikely that Ostapowicz served Lithuanian customers. Lithuanian and Polish communities were not congenial. After some years and intermarriages and wedding receptions at New National Hall (Bucket of Blood) or Lithuanian Hall, the days of feuds turned into days of old stories. (Courtesy of Frank Ostapowicz.)

These are the six handsome Sojka children in 1929, standing in front of their father's shoe repair shop. The shop looks to be near Archer Avenue, perhaps on Loomis Street. (Courtesy of Walter Kowalczyk.)

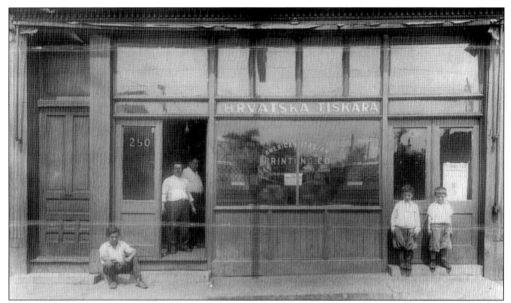

This 1920s store's name reads, "Hrvatska Tiskara (Croatian printing)." The window sign reads, "American Italian Printing Company." The mystery is if this is a joint venture or if the Italians have bought out the Croatians. The answer is not obvious; the shop is on 26th Street, where both groups lived. The mystery is unsolvable. Today, this is the location of Ricobene's Restaurant. (Courtesy of Ricobene's Restaurant.)

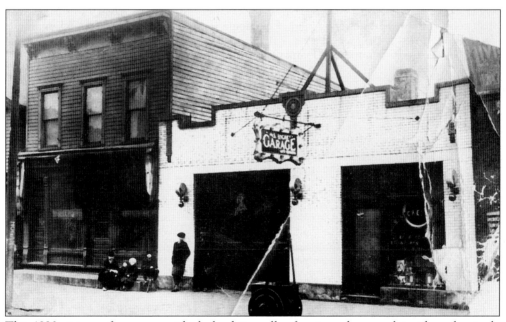

This 1920 picture of a garage, with sleek white walls of rectangular porcelain tile and a single gas pump, looks like it could be a still shot from the movie *Bonnie and Clyde*. It is James Hickey's garage on Archer Avenue and Loomis Street—not on the side of Bridgeport where folks who would have driven black limousines would have had their cars serviced. (Bridgeport had people who drove black limousines in the 1920s, but not on this side.) (Courtesy of Joe Michalek.)

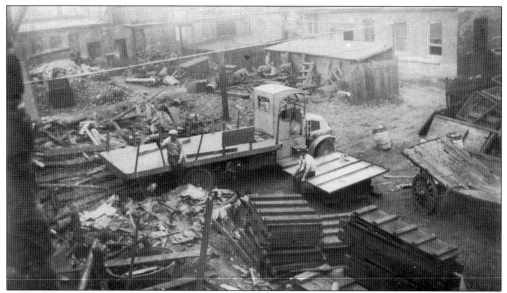

Butler foundry was established in 1891 in the heyday of wrought-iron works. It was very busy. In fact, it continued to be very busy for 120 years. The picture shows the yards of the foundry in the 1920s. (Courtesy John LaMonica.)

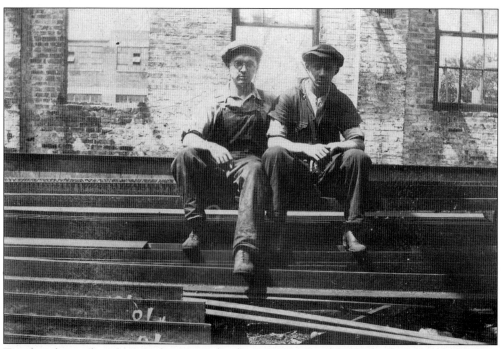

Two foundry workers from Butler sit on a break in 1920. After World War II, iron pouring—the main function of the foundry—lost value. The government determined that the environmental costs and the price to remedy them were extreme. The Butler family sold its operation to a blacksmith who endeavored to change the works into an art studio. In 2011, Butler Foundry closed its doors after 120 years of work. (Courtesy of John LaMonica.)

On 31st and Halsted Streets, across from David's, stood Friar's Open Kitchen, known as a good place for breakfast. The lovely embossed Celtic design in its metal front decoration lends some exotica. An ad on the building's eastern wall proclaims the tastiness of Canadian Ace beer, rumored to be owned by Al Capone. That beer label was pulled from the market shortly after Prohibition ended. In 1955, the FDA charged the brewery with false advertising about its owner. Lou Greenberg, the proxy owner, was assassinated at the brewery. (Courtesy of Chicago History Museum.)

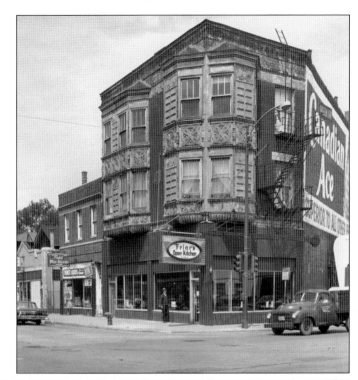

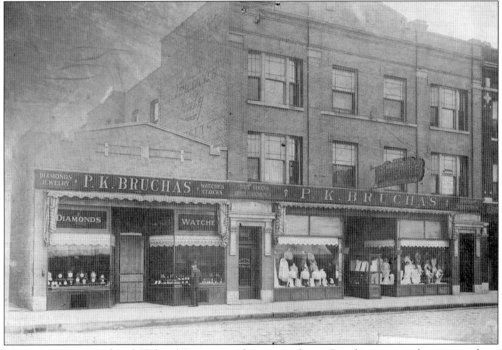

Three stores on 32nd and Halsted Streets combine to make up Bruchas—a jewelry store, a dress shop, and a music store. This picture portrays this trio in its heyday in the late 1920s. Why would anyone travel to shop in the Loop when there was a Bruchas? Not many folks from Bridgeport did. (Courtesy of Chicago History Museum.)

Bridgeport Restaurant at the corner of 35th and Halsted Streets has been a mainstay to the neighborhood's stomachs since before 1940. As always, the food is hearty and good, and the prices are affordable, making it a typical old-school diner. Bridgeport nowadays is going upscale; there is even a restaurant with a Michelin star. The Bridgeport Restaurant will never earn such a star, just the undying love of its patrons. (Courtesy of Boris Pierdolynsky.)

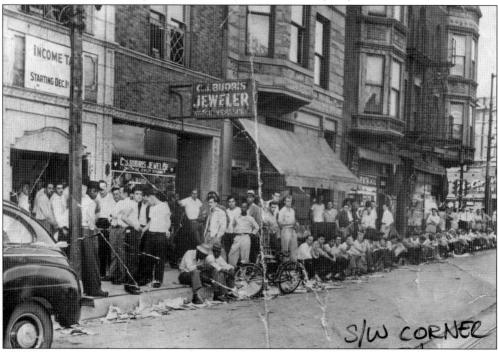

In 1940, the United States started drafting men for war. This picture depicts the South Side's youth waiting to be assessed. The line stretches west along 35th Street, turns at the Bridgeport Restaurant, then goes west down 35th Street. The line reflects both Bridgeport and America at the time, with young men—white and black, of Mexican, Polish, or Irish descent—all waiting to go off to war. (Courtesy of Chicago History Museum.)

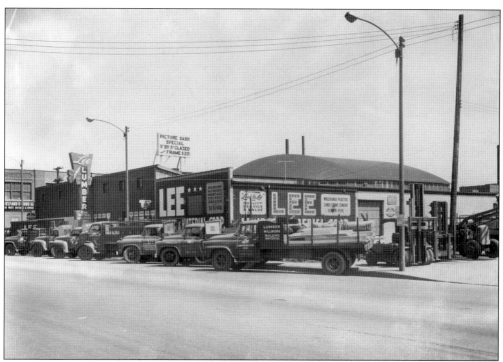

Lee Lumber was founded in 1952 on 39th Street (Pershing Road) between Howe and Union Avenues. It now has locations surrounding Chicago, but its Bridgeport location remains its home base. The company caters to do-it-yourself folks and large industrial contractors. (Courtesy of Lee Lumber.)

Lee Lumber's location on 39th Street and Union Avenue makes it accessible to both the river and the lake. It is only natural then that the boatbuilding and repair business has become part of its repertoire. (Courtesy of Lee Lumber.)

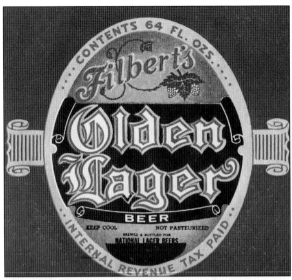

The Filbert family has been a constant in Bridgeport since they pulled a dray of milk, ice, and coal to meet their neighbors' needs. In 1926, they dabbled in root beer. At another time after Prohibition, they tried brewing and selling Olden Lager, an alcoholic beverage. But the root beer proved their talent, and their alcoholic brews, as pictured here, have faded into the past. (Courtesy of Ron Filbert.)

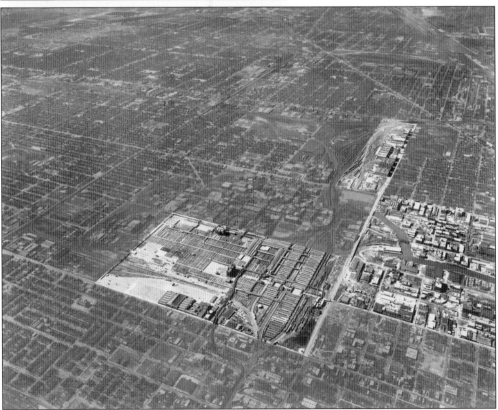

It was a revolutionary concept of a civic-and-business combination planning and building an exclusive industrial business destination. The Central Manufacturing District meant jobs for nearby Bridgeport and other communities as well as continuity for businessmen. The CMD put in utilities and roads, a bank, and a gentlemen's club and hired on an architect, Abraham Epstein, to design it. The CMD was the first privately established industrial park in the country, and it set the template for the rest of the nation. (Courtesy of David Epstein.)

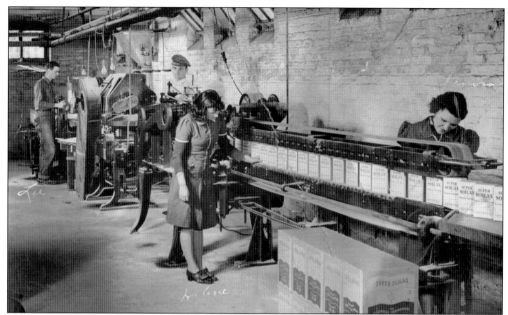

One of the first enterprises in the compound, the Soilex Company was an integral part of the CMD. It specialized in making and selling soaps designed to meet particular problems. Ultimately, it sold one of the most popular of its kind, Spic 'n Span. Unfortunately, as science grew more inquisitive about environmental concerns, the types of soaps Soilex made came under greater scrutiny, and the plant closed. (Courtesy of Ricobene's Restaurant.)

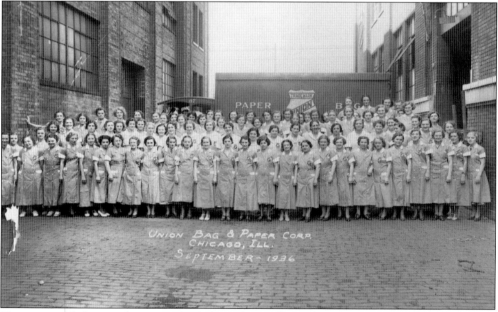

Here, assembled in uniform, are the ladies who made products for the Union Bag and Paper Company around 1936. The company was always ready to find unique ways to use its products —not just to hold things but to do things with them. In 1912, the company wrote a book, *Paper Bag Cookery*, of course, using its products. It was an efficient notion: With only paper bags, one eliminated pots and pans. (Courtesy of Ricobene's Restaurant.)

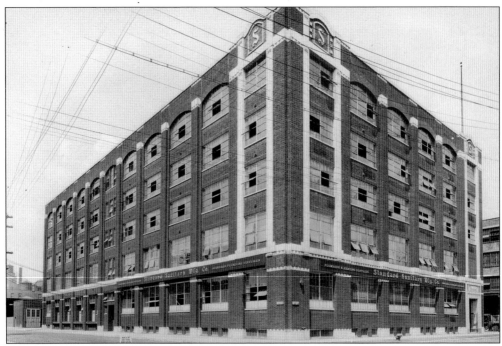

Another building of the Central Manufacturing District, the Standard Sanitary Manufacturing Company was built wholly within the specifications of the CMD's original principal architect, Alfred Alschuler (in coordination with A. Epstein). Its 1924 building is on Iron Street in the district. (Courtesy of University of Minnesota.)

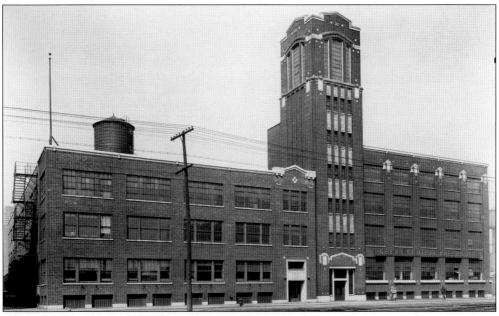

The American Glue Company building was built in the CMD in 1920 by the architect Jay Scott. The uniqueness of its design derives from the center tower of the structure; it does not hold offices but another water tower. It is just disguised in a way as not to distract from the overall aesthetic of the CMD campus. (Courtesy of University of Minnesota.)

OCTOBER 21, 1939

The Central Manufacturing District was at its height of growth during the Depression. Its collective planning facilities—provision of architects and engineers, for example—helped a business building a plant to focus on its particular enterprise and less on the details of construction. In 1933, the Burch Biscuit Company merged with the Schulze Baking Company and moved its operations from Iowa to the CMD. The company built a large facility at 1133 West 35th Street. (Courtesy of Schulze Burch Biscuit Co.)

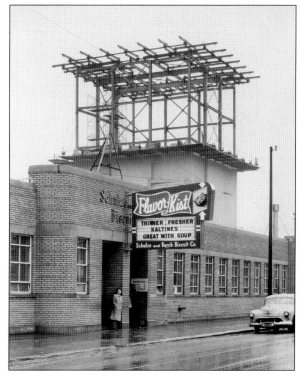

So pleased with the helped it received on the first factory, the Schulze Burch Biscuit Co. expanded its facilities in 1950. About 18,000 square feet of manufacturing space was added. (Courtesy of University of Minnesota.)

The CMD not only supplied its companies physical help—architects, engineers, utilities, and police and fire protection— but it gave the companies within its confines financial security, too. A part of the CMD system was the Central District Bank, which helped manage the companies' finances. It was open to neighborhood patrons as well. During the worst of the Depression, only one of the hundreds of businesses located in the CMD failed. (Courtesy of David Epstein.)

The CMD had an exclusive businessmen's dining club available for the executives of the companies operating in the compound. But, it did not fail the regular employees either. Inside the CMD campus itself was a workmen's cafeteria, and next to the bank, arranged by the CMD, was a Thompson's restaurant. Thompson's was a well-established Chicago-based eatery, with restaurants around the country. The food was priced reasonably. (Courtesy of University of Minnesota.)

Five

SMELLS, STRIFE, AND STRIKES

Bridgeport politics had two acts. Act one was labor versus management. Bridgeport always meant jobs. Life was hard; workers sought better conditions; labor strife ensued. Act two was Bridgeport's citizens, notably Irish citizens, discovering a remarkable talent for political organizing and exercising it locally and on a national scale.

For act one, 19th-century living in Bridgeport was awful. Waterways were sewers. The newspapers regularly condemned Bridgeport's "epidemic winds" and "odiferous, fetid and uninhabitable lands." Cowboys herded cattle through streets. Two or three houses were crammed onto lots made for one. The city raised street levels, but raising a Bridgeport house to meet the levels was unaffordable. First floors became basements; aromatic outhouses, stills, and coal bins hid below street grade (also known in Polish as "*Joe Podsajdwokiem*," meaning "Joe under the sidewalk").

Then strikes came. In 1845, the canal workers struck for back pay; they lost. In 1867, Illinois law mandated an eight-hour workday. Employees celebrated, and employers demanded 10 hours of work. Thousands strong, the workers struck, with torchlight parades that lit up Bridgeport's Archer Avenue. The workers lost.

In 1877, railway workers struck nationwide for the eight-hour workday. Pilsen Bohemians, Germans, Bridgeport Irish boys, and Poles joined in support, resisting police and militia at the 16th Street Viaduct near Halsted Street; 30 protesters were killed. The Halsted Bridge, part of the skirmish, became the sanctified "Red Bridge," awash with protestors' blood. No police died.

In 1886, the Haymarket rally took place, outside of Bridgeport; its citizens were there. Mark Sheridan students even boycotted school in sympathy with their parents. Infamous police captain John Bonfield, roughed up by Bridgeport toughs the night before, supervised the Haymarket police. (A Bridgeport street bears his name.) Someone hurled a bomb, and seven policemen died. The rally became a riot and a controversy for years.

Southern blacks migrated to Chicago, on the Illinois Central Railroad, settling east of Bridgeport in a neighborhood now known as Bronzeville. The year 1919 erupted in violent white-versus-black riots, instigated by white racism and fueled by job competition. While Bridgeport residents undoubtedly participated, most fighting occurred south of the neighborhood. There were compromises made in Chicago; business is business, with many blacks working in white areas and vice versa. Arrangements were made to transport workers—hidden under blankets—to their jobs regardless of color or the color of the neighborhood, while the fighting went on around them.

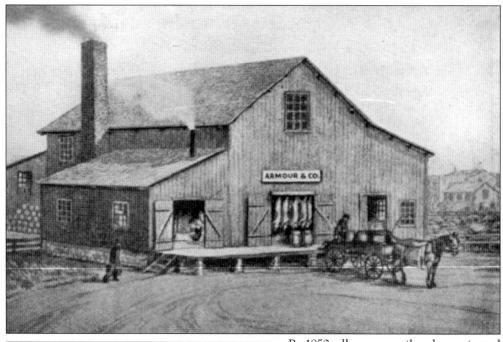

DOCUMENT 7 - COMMUNICATION FROM TEACHERS OF THE HOLDEN SCHOOL IN REGARD
TO THE HAZARD OF CATTLE IN THE STREETS

May 25, 1875

TRANSCRIPTION

Chicago May 25/75

To the Hon Board of Aldermen
of City of Chicago

We the Teachers of the Holden
School - do beg leave to present to your Hon Body
that —

Whereas there is an average daily attendance
of over 800 children &

Whereas we are in the direct rout in which
Texas and other wild cattle are driven
from the stockyard to the slaughterHouses on
Archer Ave and

Whereas the lives of those children are
in daily peril from that source

Therefore we pray that your Hon Body
will extend to us & those children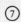
that protiction which the case demands
by the passage of an ordinance prohibiting
the driving of said cattle through our
streets between such hours of the day as will
Insure us protection

C.F. Babevek.	Prin.
Anna Patch	H. Asst.
F.E. Oliver.	Alice P. Thissell.
Ida M. Gillson	Mary J. McNamara
Julia F. M. Hull.	May F. Johnston
Jennie E Reynolds.	Fannie Day
Carrie M. Stanley.	Lottie M. Rose

By 1850, all western railroads terminated in Chicago, and the canal continued delivery to New York. Transportation attracted processors and workers. In May 1867, dignitaries ceremoniously gathered to open Armour's Archer Avenue slaughterhouses. They killed a pig, and the crowd roared. In 1865, the city moved the slaughterhouses to the Union Stockyards south of 39th Street. Bridgeport enterprises did not cease in the dumping into the river of leftovers of 400,000 hogs and 80,000 cattle killed annually—creating a perpetual stench. (Courtesy of *Chicago Then and Now*, 1933.)

Newspapers continually reported on Bridgeport's odors ("smell of a neglected morgue"). A west wind often engulfed the Loop. Charles Holden, a politician, was the namesake of Bridgeport's first school. In 1875, its teachers felt compelled to plead with the city to stop daytime stampedes of "wild cattle" down Archer Avenue, which endangered Holden's 800 students. The reply is lost, but the school later moved to 31st and Loomis Streets. (Courtesy of Daniel Feldman.)

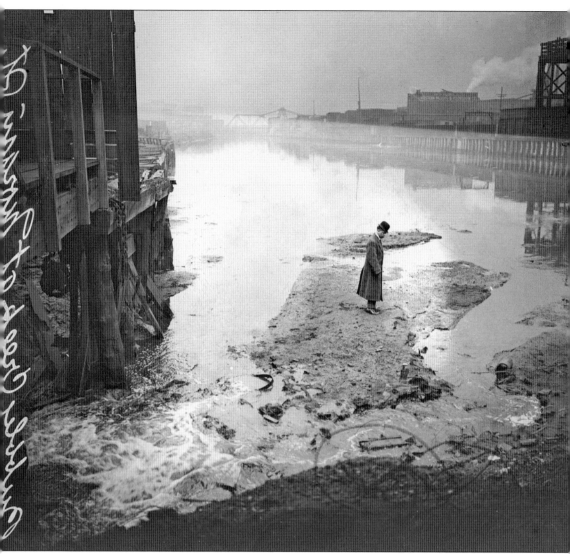

Bubbly Creek is still the locals' name for the South Branch of the Chicago River, even though prodigious cleanup efforts have reformed many of its evil waves. At the heyday of slaughterhouses, it was the sewer for remnants of hogs or cattle butchered in Bridgeport or at the stockyards. The Union Stockyards, opened in 1865, were meant to keep the processing odor away from the city, but closer-in Bridgeport never shut down its lucrative abattoirs anyway. Bubbly Creek remained a waterway of churning bubbles, burping up carbonic acid, constantly moving ossified islands of hair, grease, and lard. In his 1906 novel *The Jungle*, Upton Sinclair writes: "Many times an unwary stranger has started to stroll across [the river] and vanished temporarily." Joe Wichert, who spent his childhood blocks from the river, remembered swimming in it, "but first you had to throw a big stone in, to get the scum to part; you were on your own on the way up." (Courtesy of Chicago History Museum.)

The old buffalo path that became Archer Avenue continued into the 19th century as Bridgeport's main business district. Thousands of citizens shopped, worked, went to school, and drank there. It remained unpaved into the 20th century. This 1885 photograph depicts the 2800 block of Archer Avenue, with streetcar rails down the center of the street. The unpaved road probably helped cattle rampaging along to be processed. (Courtesy of Chicago History Museum.)

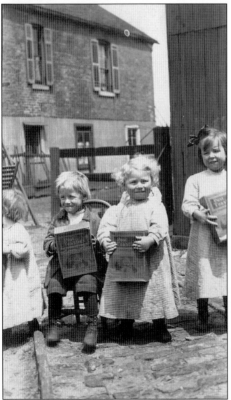

Benton House has served Bridgeport for over a century—caring for its children, teaching their parents, and assisting the aged. It opened as Ma Benton's Nursery in 1907 on 28th Street and Archer Avenue, helped by Hyde Park's St. Paul Episcopal Church. It protected these "Post Toasties" kids from Bridgeport's environment, including its smells, dirt, and tainted water. Benton House still provides services to Bridgeport folks from facilities on 31st Street and Gratten Avenue. (Courtesy of Benton House.)

There were no zoning laws, or at least, none were enforced in 1905. Streets remained unpaved and dusty in the summer, muddy in the spring and fall, and icy and snowbound in the winter. No dibs here; there was no space to protect. Residential shanties abutted industrial locations. Follow the sight line of this picture east: railcars sit mere blocks from Nativity of Our Lord Church; some railcars even snuggle in between houses. (Courtesy of Chicago History Museum.)

At the end of the 19th century, industry and population exploded in Bridgeport. Places that once were untouched prairie became businesses or tenements. This photograph at 1362 West 31st Street depicts it all. Here, the houses backed into barrel factories and coal companies, and prairies were situated across from a child scooting along a dirt road. Conditions were not ideal for health, but for folks who need jobs, it worked. (Courtesy of Chicago History Museum.)

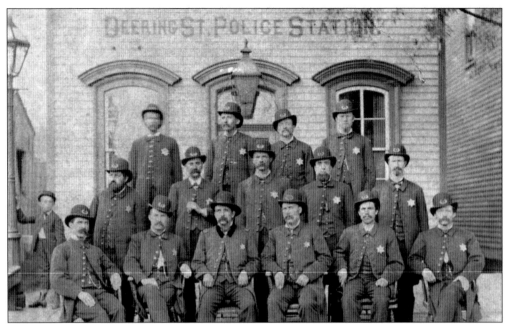

Here sit Deering (Loomis) Police officers in 1872. In 1867, they faced a nationwide labor struggle, with its heart in Bridgeport. Illinois passed the eight-hour workday law, and employers ignored it. On May 4, thousands, carrying torches, protested down Archer Avenue. The police reluctantly disrupted the march; many shared sympathy, if not bloodlines, with the marchers. The 10-hour day returned. (Photograph courtesy of Sgt. Martin Loughney; information courtesy of Jentz & Schnierov, *Chicago in the Age of Capital*, an unpublished manuscript.)

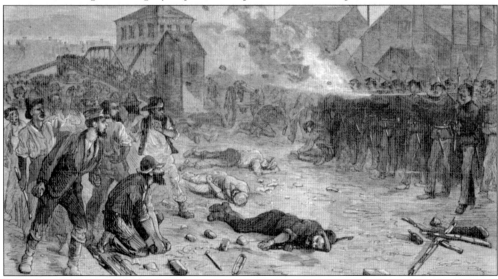

The 1877 depression hung over the nation, so management cut wages. Organizers, the Knights of Labor, and the socialists began recruiting in Chicago. A violent, haphazard railroad strike started in Maryland, spreading westward. In July, Chicagoans joined their eastern brethren in work stoppages. On July 26, 1877, a confrontation began at the viaduct near 16th and Halsted Streets, extending to the Halsted Street Bridge. Thirty citizens were killed. (Courtesy of Chicago History Museum, Jentz & Schnierov.)

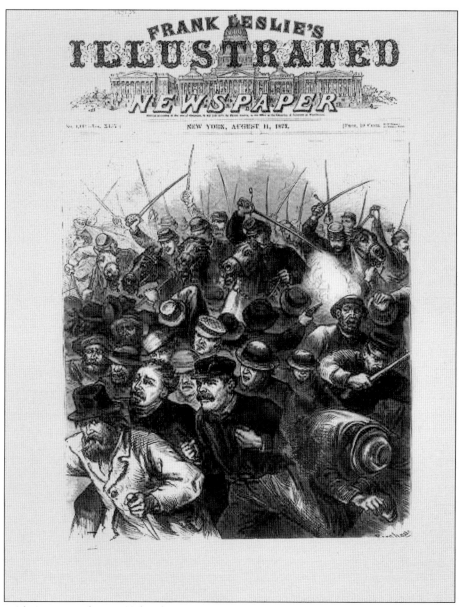

The 16th Street Viaduct at Halsted Street stood in Pilsen, a Bohemian neighborhood, across the river from Bridgeport. A few days before July 26, skirmishes between workers and police occurred at the McCormick Works. By July 26, more than 5,000 citizens, both men and women from many nationalities—Bohemians, Germans, Poles, and a large contingent of Bridgeport Irish—converged at the viaduct. Police tried to disperse the crowd, driving it south toward the Halsted Street Bridge; they shot into the crowd, clubbing people as they fell. Colonel Agramonte's federal militia charged into the melee. Action moved over the bridge, and the police followed. Someone raised the bridge, trapping police in Bridgeport. Another battle ensued until the bridge was lowered, allowing police to escape. In all, 30 citizens were killed, and many were wounded. The police and militia suffered no serious wounds. From that day, the people of Bridgeport sanctified that bridge as the "Red Bridge" in honor of the blood shed upon it. (Courtesy of Newberry Library, Jentz & Schneirov.)

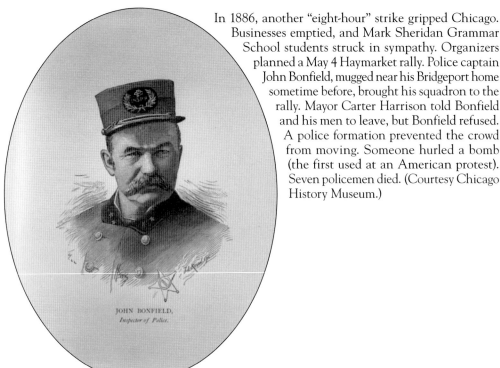

In 1886, another "eight-hour" strike gripped Chicago. Businesses emptied, and Mark Sheridan Grammar School students struck in sympathy. Organizers planned a May 4 Haymarket rally. Police captain John Bonfield, mugged near his Bridgeport home sometime before, brought his squadron to the rally. Mayor Carter Harrison told Bonfield and his men to leave, but Bonfield refused. A police formation prevented the crowd from moving. Someone hurled a bomb (the first used at an American protest). Seven policemen died. (Courtesy Chicago History Museum.)

JOHN BONFIELD,
Inspector of Police.

Haymarket organizers, convicted of murder, were executed. Governor Altgeld pardoned some, noting, "Police, under the leadership of Captain Bonfield, indulged in brutality never equaled before." Bridgeport has a Bonfield Street. Another Bridgeport policeman, Chief Francis O'Neill, served with Bonfield. O'Neill stands in direct contrast to him. O'Neill assembled Irish songs; Notre Dame University holds his collection. To O'Neill, Bridgeport neighbors were "of many races" who showed much kindness. (Courtesy of Mary Lesch.)

Six

BRIDGEPORT MAYORS RULE

"Politics ain't beanbag," says Martin Dooley, Finley Peter Dunne's 1900 fictional Bridgeport barkeep—meaning "it ain't no kids' game." A mayor of the time noted that Bridgeport's men and boys "were either hellions or early candidates for the last rites of the Church."

But brawling produced no change. Politics offered a more sustainable path to power, and Bridgeport's Irish resolved to master it. As Catholics, they related to Chicago's Catholic majority. Unlike many foreign born, they spoke English; they could talk turkey with Protestant leaders. They forged alliances—Fenian Brotherhood, Ancient Order of Hibernians, Clan Na-Gael; the 1904 Hamburg Athletic Association (Illinois's oldest licensed organization). It turns out the Irish had the knack for politics.

Anton Cermak, the Bohemian mayor in 1931, formed Chicago's first ethnic coalition, including, for the first time, African American politicians such as Bill Dawson, who switched from the Republican to the Democratic Party. In 1933, an assassin intent on killing Franklin Roosevelt murdered Cermak instead. Opportunity opened, and Bridgeport grabbed it. Pat Nash, Cook County Democratic Party chairman, appointed his protégé, Bridgeport's Ed Kelly, mayor. Kelly served until 1947. Kelly similarly welcomed blacks into the party and secured for FDR a historic third presidential term.

After World War II, some "goo-goos" ("good government" types) clamored for reform. Martin Kennelly, Bridgeport by birth and education but little else, became mayor in 1947. A millionaire Gold Coast resident, Kennelly could not control the party. A 1955 contested primary made Bridgeport's "reformer" Richard J. Daley mayor.

Until he died in 1976, Dick Daley was The Mayor and Democratic Party Chief. Daley created "the city that works" when other municipalities crashed and burned. Most Chicagoans, regardless of background, still call him "The Real Mayor."

Daley died in 1976. His factotum, 11th Ward alderman Michael Bilandic, took over. A 1979 massive snowstorm left streets unplowed and public transportation overcrowded. The city did not work;, and Bilandic shouldered blame. In the next election, Daley's secretary, Jane Byrne, considered an outsider by the machine faithful, triumphed. She served one cacophonous term as mayor of "Beirut by the Lake."

African American congressman Harold Washington beat Byrne but abruptly died in office in 1987. Eugene Sawyer, interim mayor, served until the 1989 election. Beanbag, anyone?

Richard M. "Richie" Daley, Dick Daley's and Bridgeport's son, won a hard-fought election. Chicago's longest-serving chief executive, he retired in 2011. No great racial rifts, some scandals, spectacular parks, and a commitment to the city's survival (without a lot of debt) characterized Richie's reign.

Chicagoan and turn-of-the-century newspaper columnist Finley Peter Dunne created Martin Dooley of Archey Road, a barkeep and philosopher, for his newspaper column. Dooley's observations captured both Bridgeport and national politics along with devoted readers across America. The Finucanes, Bridgeport saloon proprietors, gave Dunne his models. Dooley's wisdom resounds the following: "All politics is local"; "Comfort the afflicted and afflict the comfortable"; "Trust everyone, but cut the cards"; and "A fanatic is a man that does what he thinks the Lord would do if He knew the facts of the case." (Courtesy of Chicago History Museum.)

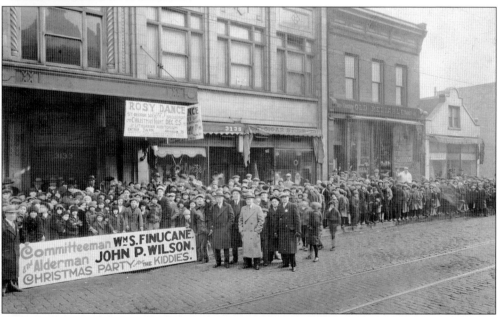

It shocks many today that Republicans were as likely to win an election in Bridgeport as the Democrats were before 1930. This picture, taken in the late 1920s, shows the Christmas party of 11th Ward Republican committeeman William Finucane (related to Ald. Thomas Finucane) in Lithuanian Hall at 30th and Halsted Streets. They owned Finucane's Hall, mentioned liberally in the Dooley columns, located near the Deering Police Station on Loomis Street and Archer Avenue. They were also related to police captain John Bonfield. (Courtesy of Chicago History Museum.)

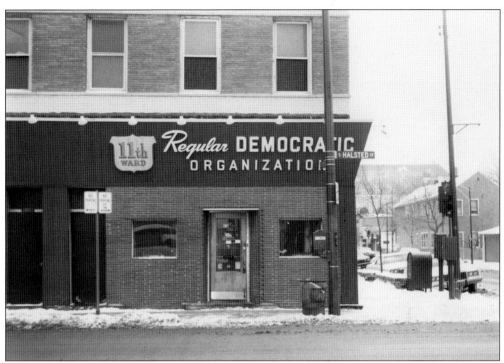

The 11th Ward Regular Democratic Organization stands on the corner of 37th and Halsted Streets. Precinct captains, alderman, and committeeman meet to decide policy and act as ombudsmen. Members are not fixers but providers of garbage cans, pothole maintenance, and essentials to the needy and help with income tax forms to people speaking Chinese, Spanish, English, Polish, Croatian, or Italian. A citizen may be evaluated for a job after a civil service test. The machine's power over services has diminished, but the organization does what it can. (Courtesy of Chicago History Museum.)

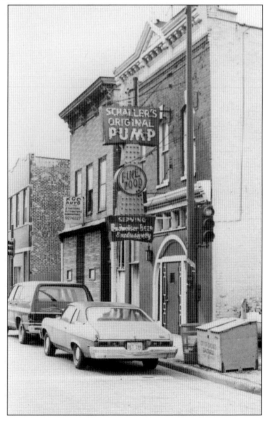

Schaller's Pump owns the oldest liquor and restaurant licenses in the city (1881). It sits on the west side of 37th and Halsted Streets, directly across from the 11th Ward Regular Democratic Organization. Sometimes, Democratic ward business may be conducted at Schaller's. Most of the time, rousing discussions about the Chicago White Sox occur. Singing is encouraged. (Courtesy of Chicago History Museum.)

Patrick Nash, Democratic chairman, surprised many choosing Edward Kelly as Cermak's replacement. Bridgeport-born Kelly had never graduated grammar school or held elective office. He was chief sanitary engineer and chief of South Park District. He fixed the "tin can dumps" and Jackson and Grant Parks, obtained donations for the Shedd Aquarium and Buckingham Fountain, and built Soldier Field. As mayor, Kelly fixed Chicago's finances. He recruited blacks as Democrats by providing jobs and encouraging school and housing integration. (Courtesy of Chicago History Museum.)

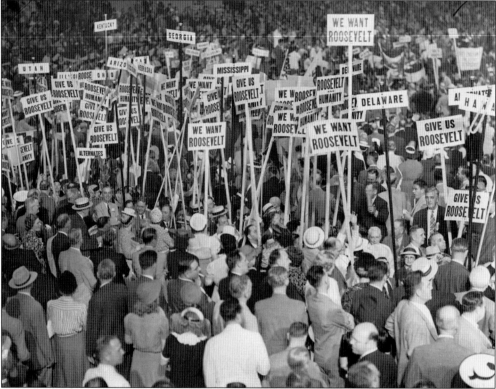

American presidents traditionally served only two terms, but in 1940, FDR faced a third term as World War II started. Mayor Kelly worried about the war; he told FDR now was not the time to "changes horses." Kelly proposed to draft FDR. A letter declining to submit FDR's name for nomination was presented at convention in the old Chicago Stadium, but the building's sound system suddenly failed—that is, everything save for one microphone in the basement manned by a commissioner of the sanitation department, Tom Garry (the "Voice from the Sewers"). Garry's shout rang through the hall: "We want Roosevelt!" Bridgeport residents smuggled in with signs bearing the message echoed the call, swarming the convention. Roosevelt was nominated for a third term, and later a fourth term. It is hard for many to imagine World War II success without an FDR presidency. (Courtesy of Chicago History Museum.)

Martin Kennelly succeeded Ed Kelly as mayor of Chicago in 1947. Kelly was a son of Bridgeport, born near 29th and Poplar Streets, just behind Mark White Square Park (an arrow indicates the home of Kennelly's birth). But he left Bridgeport as soon as he could, moving to the North Shore. Kennelly became a millionaire building his successful Allied Van Lines moving business. The marriage between Kennelly and the Chicago machine was not made in political heaven. He was a strict reformer and not the naive fellow the party's heavyweights assumed they could manipulate. After two terms, they parted ways. (Courtesy of Chicago History Museum.)

Ed Kelly left his post as mayor on good terms with the party and Chicago's citizens. He settled in Hyde Park. In this photograph, Kelly is swearing in Martin Kennelly for Kennelly's first term. Kennelly's rigidity and his refusal to continue integration efforts did not buy him much goodwill when it came to reelection. (Courtesy of Chicago History Museum.)

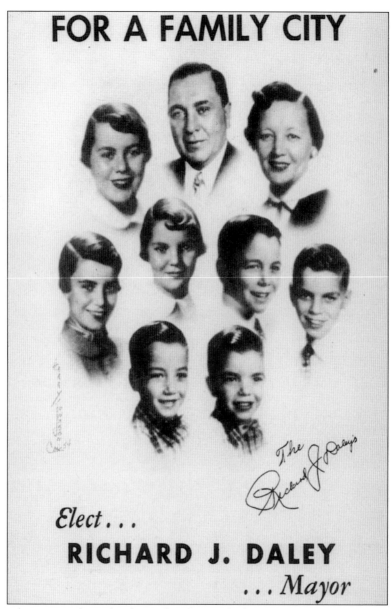

FOR A FAMILY CITY

Elect...

RICHARD J. DALEY

...Mayor

This political poster made Richard J. Daley mayor of Chicago in 1955. It reflects his personal values. Dick Daley was, in this order, a family man, a Catholic, and a Democrat. One more thing, to paraphrase another famous city citizen, he was a Chicagoan, Bridgeport-born. Not only was Daley born in, but he lived and died in Bridgeport, and there is no other of the five Bridgeport mayors of whom this can be said. Daley spent his life defending the city and his neighborhood. Although great events occurred during his tenure—riots, financial crises, criminal scandals, fire, and weather tragedies—the invariables of his office were stability and effectiveness; he made the city work. Everyone—his enemies, his political opponents, and the city's population (both black and white)—admired that constancy. Indeed, his only known act of recklessness happened in 1959: Daley ordered the air-raid sirens to blast when his beloved White Sox won the American League pennant. Northsiders, somewhat confused, believed a Russian air strike was imminent. The fire commissioner took the blame. (Courtesy of Ricobene's Restaurant.)

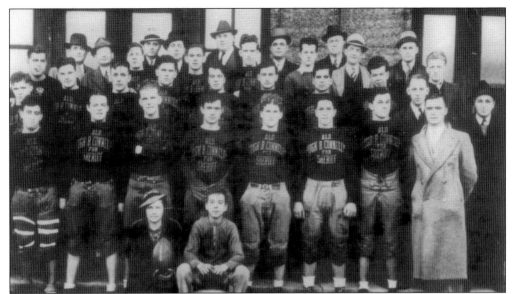

In 1937, Hugh Connelly, 11th Ward committeeman, sponsored a football team. Standing the middle of the fifth row and wearing a Borsalino hat, Connelly is the tallest man in the row. To his left is Dick Daley, Bridgeport's Republican state senator. (Democrats organized a write-in on the Republican ballot for Daley.) For all Daley's work, his reward might have come sooner, but he was no party troublemaker, unless he had votes. Others in the photograph include Mark White, John McGuane, and Dan Ryan, the so-called patron saint of expressways. (Courtesy of Celeste Gazarek.)

The Daley home at 35th Street and Lowe Avenue is a bit larger than some on the block. Built after Daley achieved his first elective office, this was home to Dick, his wife, Eleanor "Sis," and their seven children—Patricia, Mary Carol, Eleanor, Rich, Michael, John, and William. Their in-laws lived with them, too. Daley's grandson now inhabits the bungalow, but the house is still a mainstay on any Bridgeport tour. (Courtesy of Marek Dobrzycki.)

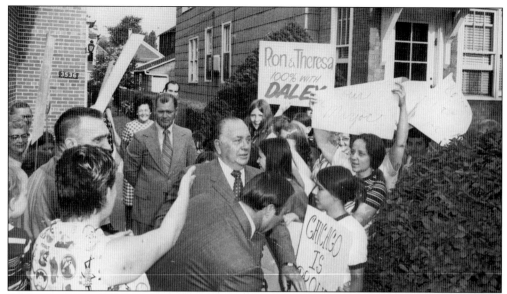

Bridgeport counted on Richard J. Daley. Steadfastly, Daley counted on Bridgeport. This reciprocity derived not from a cynical barter of jobs for votes, but from a shared trust. Regardless what "side" someone was from, there was that moment at a wake when mourners hushed and somebody said, "The mayor's coming." Similarly, neighbors helped beyond the ballot. Here, the Rupkes from down the block gather in Daley's gangway for a photo opportunity to show support for his campaign. (Courtesy of Frank Sorich.)

The 11th Ward traditionally provided holiday food baskets to the needy. A precinct captain is expected to know the territory and which voters might need extra help. Here, Mayor Daley and some precinct captains in the 1960s prepare to deliver bags of food. Services did not stop at food. For example, clothing drives, help on income tax forms (in many languages), providing garbage cans, and transportation all fell with the scope of duties. (Courtesy Frank Sorich.)

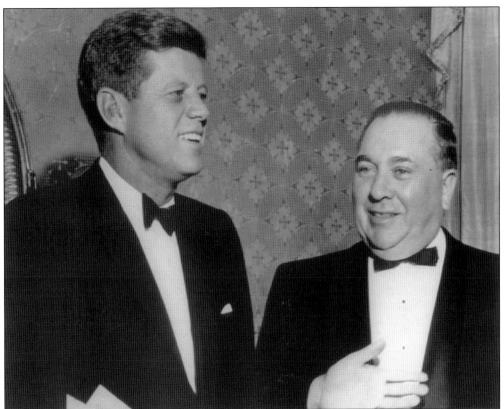

Mayor Kelly's political organization continued to strengthen. The Chicago Democrats, lead by the 11th Ward, became more than a local power. As Democrats increased their plurality in elections, its leaders and voters achieved national power, too. It was not uncommon for national leaders to visit Mayor Daley at his home in Bridgeport. President Carter did; Vice President Mondale did. Here, Mayor Daley welcomes John F. Kennedy to 35th Street and Lowe Avenue. (Courtesy of *Chicago Tribune*.)

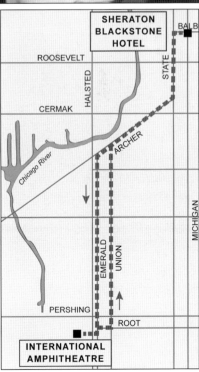

The 1950s and 1960s conventions, held at the International Amphitheater, reflected Chicago's political power. Delegates stayed downtown but drove through Bridgeport to the amphitheater. In early evening, when they drove down Emerald Avenue, crowds lined the street good-naturedly jeering Republicans and cheering Democrats. At night, the party moved one block east to Union Avenue. Bridgeport citizens gained a special collection. They saw every contemporary politician, including Eisenhower, Stevenson, Kennedy, Nixon, Goldwater, Reagan, Rockefeller, McCarthy, Humphrey, Johnson, Mondale, and more. (Map design by Julie Joseph.)

Mayor Richard J. Daley's private world centered on his family and his parish, Nativity of Our Lord, where he had served as an altar boy. His seven children studied there. Most Bridgeport Catholics sent their children to parochial schools at the time of Daley's mayoralty, and every Catholic and many Lutheran churches had grammar schools. Bishops consecrated the new Nativity School in 1962. This laying of the cornerstone is a nonpolitical event the mayor would not miss. (Courtesy of Frank Sorich.)

Mark White Square Park, the largest park in Bridgeport, was renamed McGuane Park some time ago. This photograph shows three mayors: second from the left is then Alderman Bilandic, who succeeded Mayor Richard J. Daley; the man standing to the right of the sketch is Mayor Richard J. Daley; and standing next to him is his son, a very young-looking Richard M. Daley, who went on to become the longest serving mayor of Chicago. Looking at them, their pride and happiness suggest that the presentation reminds them of times spent playing baseball, tennis, swimming the "Big Pool," or skating on the frozen field (with a real woodstove in the hothouse). (Courtesy of Frank Sorich.)

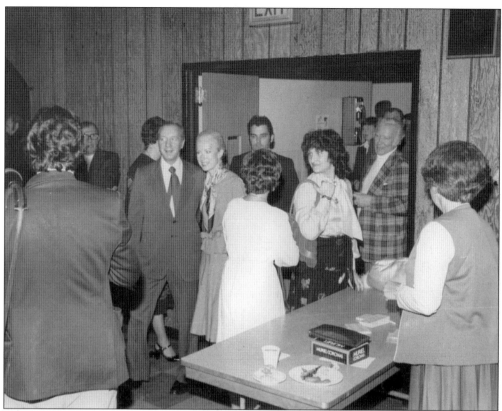

Michael Bilandic was an unexpected mayor with an unlikely name. Unlike other Bridgeport mayors, he was not Irish but Croatian, a "moji" in Bridgeport lingo. Bilandic was from the "other side," St. Jerome's Parish, and was a World War II Marine veteran, but he was also a Daley man and the 11th Ward alderman. In 1976, Dick Daley suddenly died. Bilandic emerged as the compromise for interim mayor upon the promise of no separate term. He married Heather Morgan. Here, the couple walks into the 11th Ward Office. (Courtesy of Frank Sorich.)

Bilandic had a son. The press loved the shot of a mayor in scrubs. Family life was going well, but city hall—not so much. Strikes hit the city. Mother Nature's wrath provoked the city's third worst snowstorm ever in January 1979. Bilandic relied on a patronage employee's ineffective snow removal plan. Bilandic found it difficult to publicly acknowledge the snow. Next election, he lost the mayoralty to a Northwest Side woman, Dick Daley's secretary, Jane Byrne—definitely not from Bridgeport. (Courtesy of Jack Lenahan.)

Richard M. Daley, Dick Daley's son, was never anointed "prince." Those who knew Rich knew that he earned every office he held. He worked his way up, but his name helped—especially in Bridgeport. This picture shows him as a harried state senator. Rich later became state's attorney. In his first mayoral race, he lost; he won the second. Rich ended up being the longest-serving mayor Chicago has had to date. (Courtesy of Frank Sorich.)

Rich Daley won his second try at mayor of Chicago. Here, he and wife, Maggie, leave their Bridgeport home at 33rd Street and Emerald Avenue to cast their votes. Rich, Maggie, and family moved out of Bridgeport to the South Loop while he was mayor. Some folks in Bridgeport were disappointed. But, in the end, neither the city nor Bridgeport could be disenchanted with the Richard M. Daley mayoral era. Maggie Daley unfortunately died in 2011. Rich retired as the longest-serving mayor in Chicago's history, another proud son of Bridgeport. (Courtesy of Marek Dobrzycki.)

Seven

GETTING AROUND

Transportation lies at the root of the dynamic growth that Chicago bedazzled the world with, bringing to fruition the promise of the canal first prophesied centuries earlier by Jolliet and Marquette on their travels along the prairie shores. From carving the earth with ribbons of waterways to the rivers of steel, Belgian block, concrete, and asphalt that later followed, each new technology left its indelible mark on Bridgeport. As transportation improved with each successive mode, industry expanded farther, taking advantage of the seemingly endless supply of labor seeking to satiate the seemingly endless need for manufactured goods in the New World. The nondescript fur-trading outpost of the Heacocks, Beaubiens, Leighs, and LaFramboise was enveloped by the metropolis of the mid-continent that sprung up from it.

On a humbler scale, the means of transportation throughout Bridgeport has changed over time, as new machinery, trends, and innovations slowly but surely pushed out older forms of transit. These are vintage photographs of how people in Bridgeport have gotten around the area in the past. These old shots of streetcars as well as the old "green limousine" buses are sure to stoke memories for older residents in the vicinity and help to give others an idea of what life was like in those olden days.

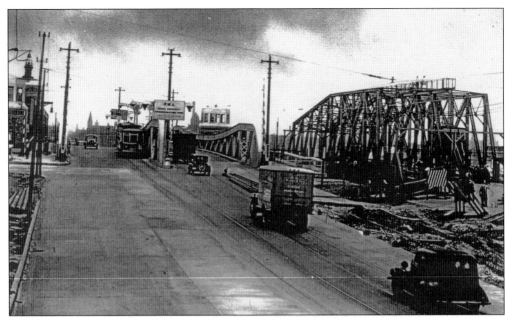

Bridges not only lent Bridgeport its name, they helped connect the neighborhood to the rest of the city. Whether it was for folks heading to Pilsen, as in this shot, or the plethora of other destinations, there was no shortage of options when it came to public transit. This same bridge is still in use for automobile traffic, while the adjacent rail bridge has been since dismantled without a trace. (Courtesy of Chicago Transit Authority.)

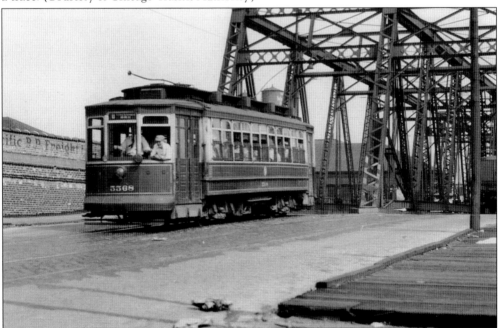

Crossing the Halsted Street Bridge is a streetcar headed for Bridgeport. Much of the city owes its residential growth to the expansion of the streetcar lines through the area. In contrast to the more expensive railroads, they were affordable transportation for members of the working class. (Courtesy of Chicago Transit Authority.)

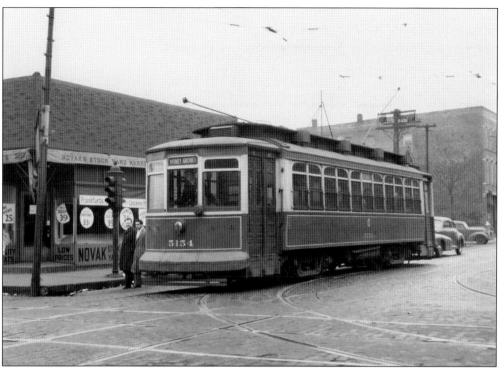

Folks at Halsted and 31st Streets are getting off the streetcar in front of Novak's Stockyard Market. Plenty of residents living in Bridgeport recount taking the Halsted Street streetcar to see movies at the majestic Ramova Theatre in the old Lithuanian Downtown, 35th and Halsted Streets. (Courtesy of Chicago Transit Authority.)

This is the streetcar barn for the Chicago Railways at Pitney Court and Archer Avenue. Like the streetcars in Chicago, this building is no more. (Courtesy of Chicago Transit Authority.)

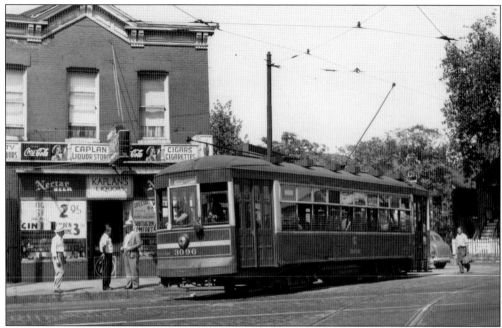

The intersection of Morgan and 31st Streets is a familiar sight in its earlier incarnation; Kaplan Liquors (now Maria's Community Bar) was a familiar neighborhood landmark until recently. A close inspection of this photograph will show, perplexingly enough, two different spellings of *Kaplan*. (Courtesy of Chicago Transit Authority.)

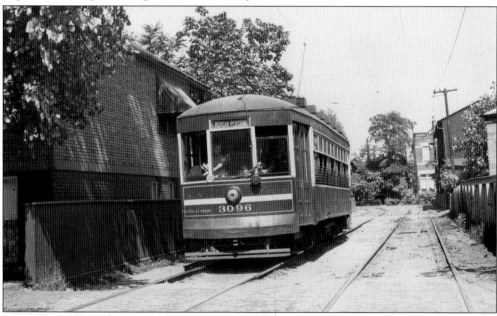

The Morgan Street streetcar travels down Farrell Street. The fact that this is the older part of the neighborhood is easily discernible from the plethora of narrow streets like this one that defy the city's grid, lining up with Archer Avenue. One has to travel far outside the region to the northwest side to find where Chicago's orderly street layout similarly goes awry, along Milwaukee Avenue in Avondale and Jefferson Park. (Courtesy of Chicago Transit Authority.)

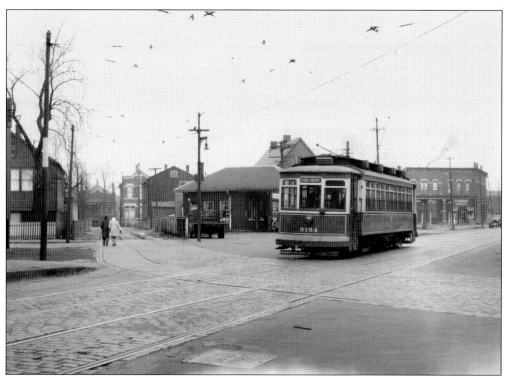

A streetcar travels west on 31st Street, just east of Morgan Street around 1950. (Courtesy of Chicago Transit Authority.)

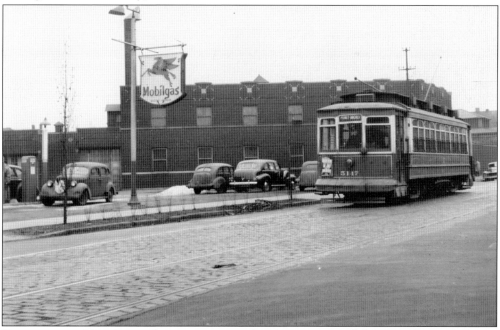

Here is a view of 31st Street where it intersects Throop Street. A Mobilgas sign shows a hallmark of the still nascent automobile industry, the now familiar gas station. (Courtesy of Chicago Transit Authority.)

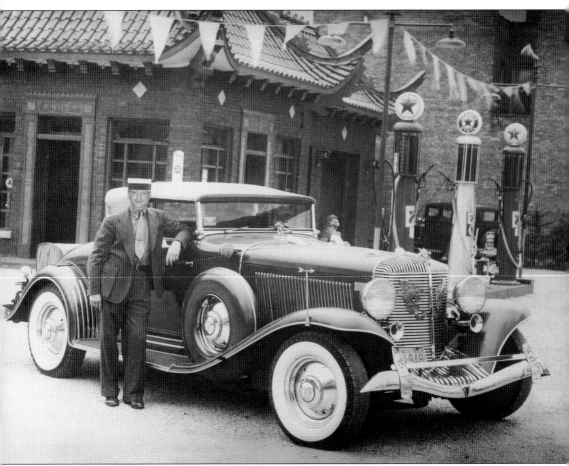

The fanciest gas station in Bridgeport is pictured here. An unidentified gentleman is beaming with pride in front of his new car at this Texaco station. The automobile inevitably replaced the streetcar as the primary mode of transportation for the average Bridgeport resident the same as it did across much of the United States. (Courtesy of Ricobene's Restaurant.)

A view of Halsted and 26th Streets on July 7, 1955, shows the street before the once recognizable sight of streetcar tracks amidst Belgian block was paved over by asphalt. (Courtesy of Chicago Transit Authority.)

Less than half a year later, on December 14, this view is of the same intersection with the streetcar tracks now covered over by asphalt. Few folks are aware that Chicago once possessed the largest streetcar network in the entire world. (Courtesy of Chicago Transit Authority.)

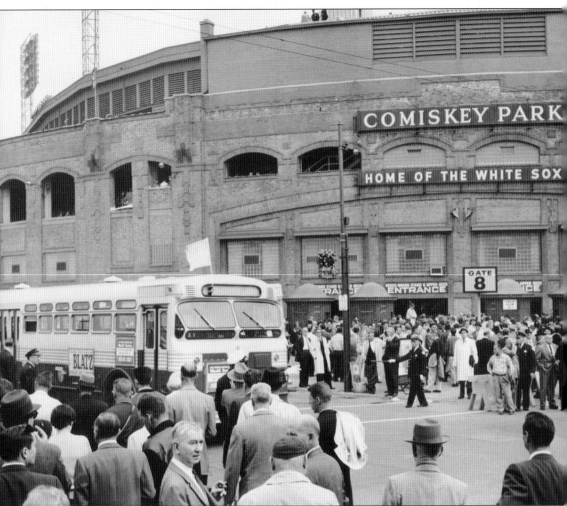

A Chicago Transit Authority bus is in front of the now demolished Comiskey Park. The "green limousines," as native Chicagoans referred to these buses, replaced the network of streetcars that ran throughout the city. (Courtesy of Chicago Transit Authority.)

Eight

FUN AND GAMES

The residents of Bridgeport have always been a hardworking lot, but they certainly enjoy playing hard, as well. While the venue can vary—be it alley, stoop, or street—the neighborhood park has long been the top spot to gather for recreational hijinks. Giving the neighborhood its center, the local park acts as a community hub for residents, a place where they can relax and play in these natural oases amid the city's hustle and bustle. Thanks to the foresight of Chicago's Progressive civic leaders, such as Jane Addams and Ellen Gates Starr, these green spaces set aside by prior generations still serve Bridgeport today. Whether through play, performance, or even the occasional outdoor film screening, the park functions as the site where the neighborhood comes together.

The city's motto is *Urbs in Horto*, a Latin phrase that translates into English as "City in a Garden," an expression that Chicago today stridently aspires to live up to. In recent years, there has been a dedicated campaign to beautify these shared spaces all over the city, a move that has also helped revitalize Bridgeport. On the site of the former Stearns' Quarry, the new Henry C. Palmisano Park and Nature Center is perhaps one of the most interesting recreational areas in the entire city of Chicago. Dubbed by locals as "Mount Bridgeport," the rising hills bestow visitors unparalleled views of the surrounding area, mimicking the summit of the "Polish cathedral" of St. Barbara Church nearby. Joining the other spires and steeples of Bridgeport's cityscape, this natural temple has now become an inextricable part of the neighborhood.

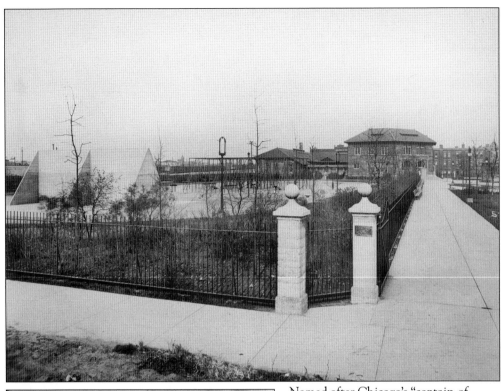

Named after Chicago's "captain of industry," Phillip D. Armour, Armour Square and its sister parks of the South Park Commission were described by Pres. Theodore Roosevelt as "the most notable civic achievement in any American city" when they opened to the public in 1906. These green spaces were created to help alleviate the crowded conditions in neighborhoods such as Bridgeport, which at the time had nearly twice as many people living there as do today. (Courtesy of Chicago Park District.)

In 1913, Hinky Dink Kenna, the notorious First Ward alderman, sponsored a baseball team called the Hinks Aid Association. The team's home field was Mark White Square at 29th and Halsted Streets. (Courtesy of Joseph Wichert.)

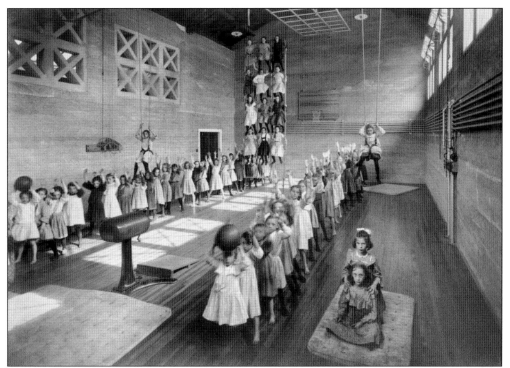

Another one of the 10 parks of the South Park Commission, McGuane Park was originally named after Mark White, the beloved superintendent of the South Park Commission for two decades. In 1960, the Chicago Park District renamed it for John F. McGuane, a civically active World War I veteran who lived across the street from the park all of his life. (Courtesy of Chicago Park District.)

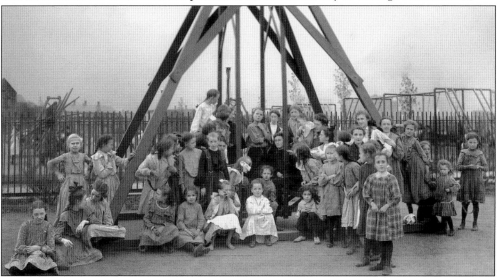

Children pose for a photograph while at play in what was then Mark White Square. Not many folks are aware that McGuane Park was designed by nationally renowned landscape architects the Olmsted Brothers and the firm of Daniel H. Burnham and Co., who were responsible for planning the entire system. These 10 parks would serve as a blueprint in the development of other parks all over the United States. (Courtesy of Chicago Park District.)

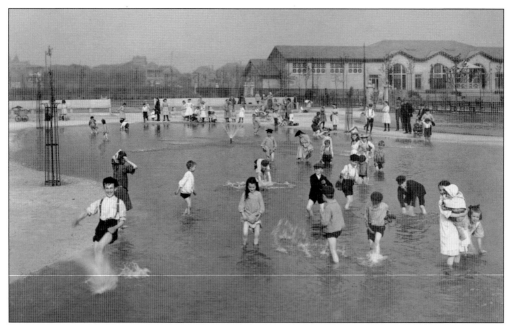

Known as the "Little Pool," this was a gathering hole for quick relief from Chicago's notoriously hot, muggy summers. This image shows how local parks fulfilled the aims the Progressive reformers set for them by creating a place for the neighborhood to come and play. It was out of these bonds that a community formed. The site is now a baseball diamond. (Courtesy of Chicago Park District.)

This shot shows the construction of the "Big Pool" at McGuane Park. The park's original field house was demolished and replaced with a new building at this time. (Courtesy of Chicago Park District.)

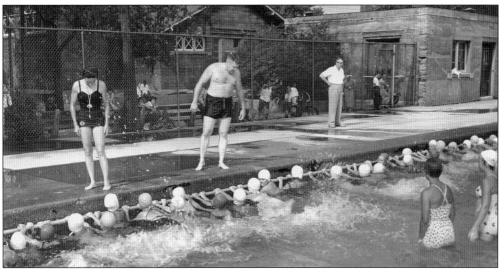

The cold waters of the Mark White Park outdoor "big" swimming pool are shown just after construction was completed. A swim here was often followed by a treat of a hot dog or tamale from a local cart vendor. (Courtesy of Chicago Park District.)

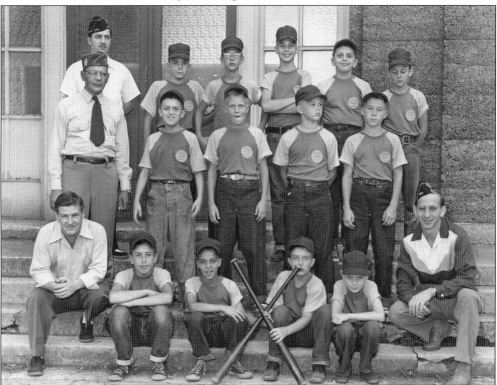

As American as apple pie, this photograph of the American Legion Post 939 baseball team is a testament to the wisdom the Progressive movement had in lobbying for the creation of green spaces. Bonds formed through play at these parks crossed lines of ethnicity, creed, and class, helping Bridgeport and other Chicago neighborhoods forge a common identity. Children still gather in Bridgeport's parks to play Little League. (Courtesy of Chicago Park District.)

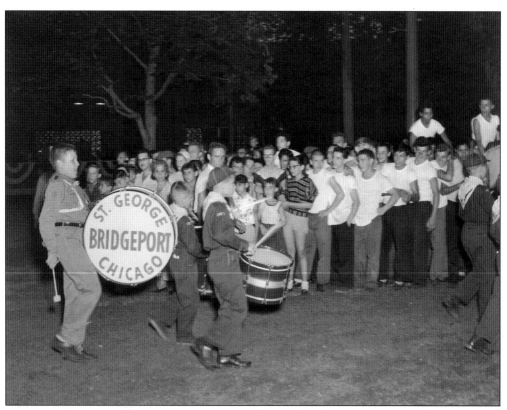

The neighborhood park is not only a place for play, but for community gathering as well. This park parade at Mark White Square shows a Cub Scout troop from St. George Parish, the now demolished mother church of Chicago's Lithuanian community. (Courtesy of Chicago Park District.)

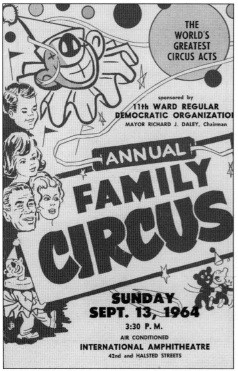

This is the program for the very popular 11th Ward Regular Democratic Organization–sponsored free Family Circus at the International Amphitheater on 43rd and Halsted Streets in the Canaryville neighborhood, located just south of Bridgeport. (Courtesy of Nativity of Our Lord Parish.)

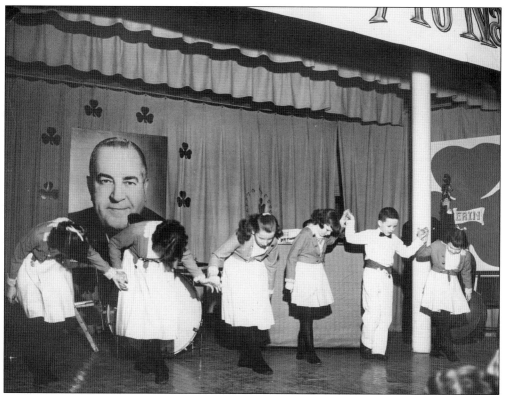

Churches were also places for community gatherings. This image shows celebrations for St. Patrick's Day in the Nativity church basement. (Courtesy of Nativity of Our Lord Parish.)

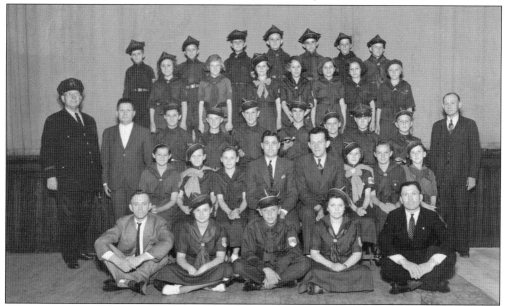

All different ethnic groups in the neighborhood took advantage of Mark White Square. This photograph shows a troop of Polish Boy and Girl Scouts, or Harcerze, a part of the worldwide Harcerstwa movement. (Courtesy of Chicago Park District.)

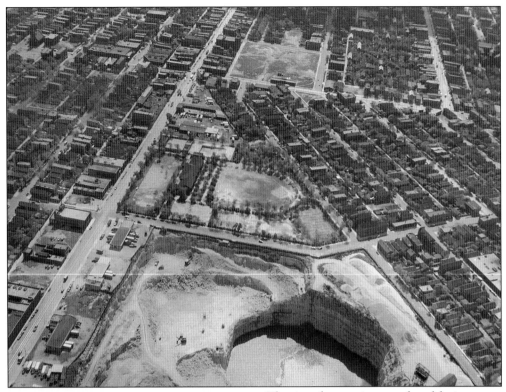

The site of an ancient coral reef dating back to the Silurian period more than 400 million years ago, Stearns' Quarry began in the 1830s as the property of the Illinois Stone and Lime Company. Marcus Cicero Stearns eventually took over the business, and the quarry continued operations under his name until 1970. (Courtesy of Chicago Park District.)

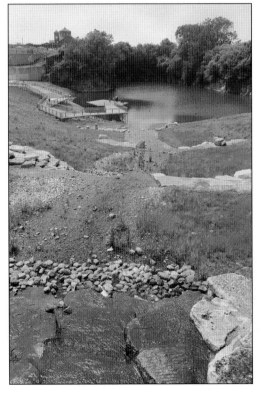

The Palmisano Nature Center was created in 2010 on clean-refuse landfill in Stearns' Quarry. Chicago's newest park, the nature center is now one of the favorite spots for locals. It boasts a 33-foot hill nicknamed "Mount Bridgeport" and beautiful vistas of both the downtown skyline and the infamous soon-to-close Fisk coal-fired power plant. (Courtesy of Marek Dobrzycki.)

Initially known as Sangamon Park, Donovan Park is one of three Chicago parks named in honor of firemen who perished in a catastrophic fire on March 1, 1957—Capt. George L. Donovan, who perished along with fellow firefighters Howard J. Strohacker and Sylvester L. Pietrowski. An old friend and neighbor of Mayor Richard J. Daley, Donovan lived just three blocks east of the Bridgeport Park that now bears his name. (Courtesy of Chicago Park District.)

Pictured is McKeon Playlot Park. This image illustrates how neighborhood parks brought people together through leisure and play, realizing the aims of Progressive activists like Jane Addams who championed the "small parks" movement. (Courtesy of Chicago Park District.)

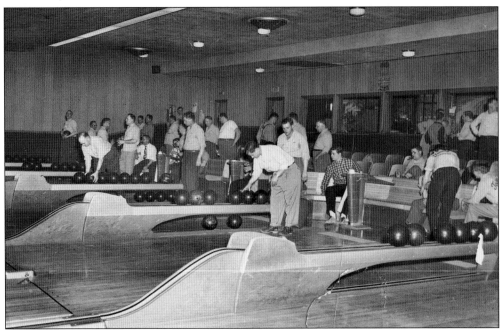

Getting together for a good game is not just the domain of street hockey and stickball. Naponiello's Bowl was the place for bowling in Bridgeport. (Courtesy of Joe Naponiello.)

Nothing gets folks going like a good competition, as can be seen this image of these champs at Naponiello's Bowl. (Courtesy of Joe Naponiello.)

Nine

BASEBALL PALACE
OF THE WORLD

Since 1900, the Chicago White Sox (named Chicago White Stockings 1900–1903) major league baseball club has owned Bridgeport's southeastern corner.

On July 1, 1910, Comiskey Park opened at 35th Street and Shields Avenue to a roaring crowd of 28,000 fans, quickly becoming one of Chicago's most historic locations. Named after team owner Charles Comiskey, the new, modern park, made of steel and concrete, was built to replace the Chicago Cricket Club's South End Grounds at 39th Street between Wentworth and Princeton Avenues. Comiskey lauded the new park as the "Baseball Palace of the World," and his team set about winning titles. Winning their first American League pennant in 1901 as the White Stockings and their first World Series championship in 1906 and their second in 1917, the White Sox would go on to top the American League once more under Comiskey in 1919, resulting in the infamous "Black Sox" gambling scandal some blamed on Comiskey's underpayment of players. In 1926, the park was renovated and expanded by double-decking most of the stands. Comiskey died in 1931, and his family owned the club until 1959, when an ownership group, including longtime baseball owner, promotions innovator, and showman Bill Veeck, acquired the team and took it again to the World Series that year.

The baseball palace hosted several historic firsts, including baseball's first All-Star game, held in 1933 as an exhibition game at the Chicago's World's Fair. The Negro League also hosted its first All-Star games at the park in the 1930s. In 1947, Larry Doby broke the American League's color barrier at Comiskey Park when the Sox hosted Doby's first game as a player with the visiting Cleveland Indians. Shortly thereafter, the White Sox signed their first Negro League player, Minnie Minoso.

In 1980, Jerry Reinsdorf and Eddie Einhorn purchased the White Sox and are still part of the collective that owns the team today. Great White Sox teams of the television era include the 1959 Go-Go Sox, the late-1970s South Side Hitmen, the 1983 Winnin' Ugly divisional champs, and, of course, the 2005 World Series champions.

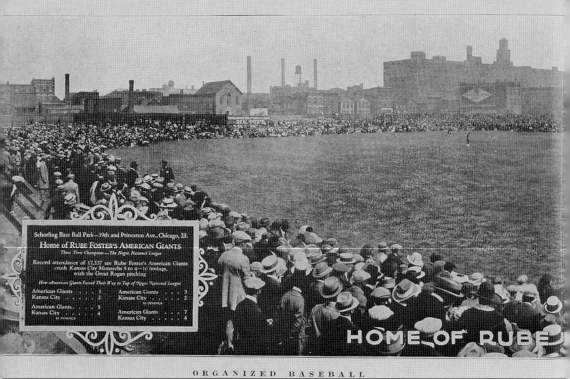

Schorling Base Ball Park—39th and Princeton Ave., Chicago, Ill.
Home of RUBE FOSTER'S AMERICAN GIANTS
Three Time Champions—The Negro National League
Record attendance of 17,337 see Rube Foster's American Giants
crush Kansas City Monarchs 5 to 4—10 innings,
with the Great Rogan pitching

How American Giants Forced Their Way to Top of Negro National League

American Giants	3	American Giants	3
Kansas City	2	Kansas City	2
			10 INNINGS
American Giants	5	American Giants	7
Kansas City	4	Kansas City	4
10 INNINGS			

HOME OF RUBE

ORGANIZED BASEBALL

South Side Park was the original home of the Chicago White Sox. The third of four ballparks built in the neighborhood, it was located on the north side of 39th Street (Pershing Road) at the intersection of Princeton Avenue. In 1900, Charles Comiskey built a wooden grandstand on the site, making it the first home of the White Sox, then a minor league team. In 1901, the White Sox graduated to the major leagues and played games here until June 27, 1910. The Sox abandoned the 15,000-capacity wooden ballpark in the middle of the 1910 season, once the team's new, larger steel-and-concrete Comiskey Park was finished three blocks away. Schorling's/South Side Park is famously known as the field where the White Sox beat the Chicago Cubs to win the 1906 World Series. In 1911, South Side Park became the home of the Chicago American Giants

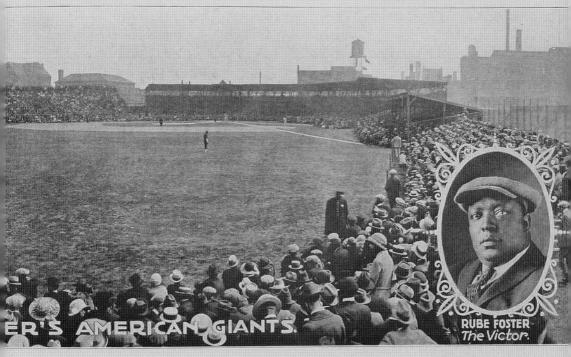

ER'S AMERICAN GIANTS.

RUBE FOSTER
The Victor.

THIRTY-NINTH STREET AND PRINCETON AVENUE

of the newly formed Negro League. The team was owned by African American Rube Foster and his business partner, John C. Schorling. The park was renamed Schorling's Park after John leased it for the American Giants. Schorling was a South Side saloon keeper and son-in-law of White Sox owner Charles Comiskey. The American Giants played their games at Schorling's through the 1940 season, when the park was destroyed by fire on Christmas Day. The American Giants would play their remaining 10 seasons at Comiskey Park, which also served as the home of the first Negro League All-Star Game. Today, the Chicago Housing Authority's Wentworth Gardens housing project occupies this site. (Courtesy New York Public Library.)

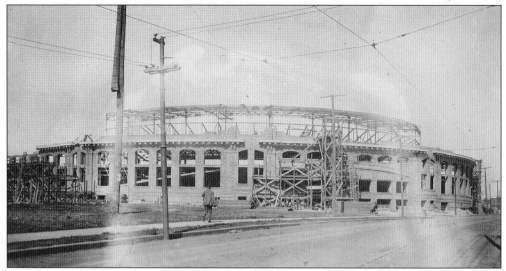

The Chicago White Sox were founded by Charles Comiskey, son of a Chicago political boss. In 1894, Comiskey purchased the Sioux City Cornhuskers, a professional baseball club. After moving to St. Paul, Minnesota, in 1900, the team soon relocated to Chicago's Bridgeport neighborhood to South Side Park at 39th and Princeton Streets, first taking the team name Chicago White Stockings, then finally Chicago White Sox, in 1901. Pictured under construction is their home for over 80 years, Comiskey Park at 35th Street and Shields Avenue. The fourth steel-and-concrete stadium built in major league baseball, the 1910 park seated a then record 29,000. It was designed by Chicago architect and Armour Institute (Illinois Institute of Technology) alumnus Zachary Taylor Davis. (Courtesy of Chicago History Museum.)

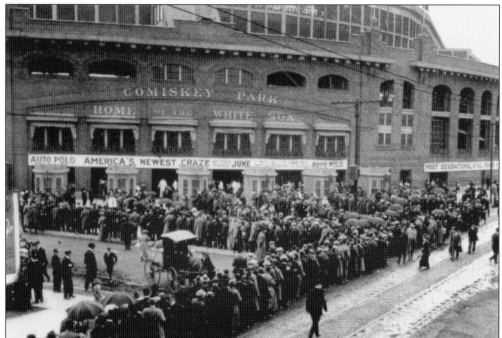

The Baseball Palace of the World, as it was called by owner Charles Comiskey, opened to record crowds on July 1, 1910. (Courtesy of Sherri Senese.)

Here is McCuddy's in 1910. Located directly across 35th Street from Comiskey Park, McCuddy's opened in February 1910. A tavern, kitchen, and barbershop owned by the Senese family (Pat and Pudi), McCuddy's became famous for hosting thirsty ballplayers from around the American League before, after, and in between doubleheader games. (Courtesy of Sherri Senese.)

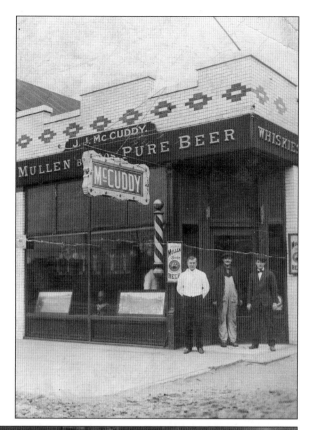

On opening day of the 1910 season for the White Sox, George Lyons is tending bar at McCuddy's. (Courtesy of Sherri Senese.)

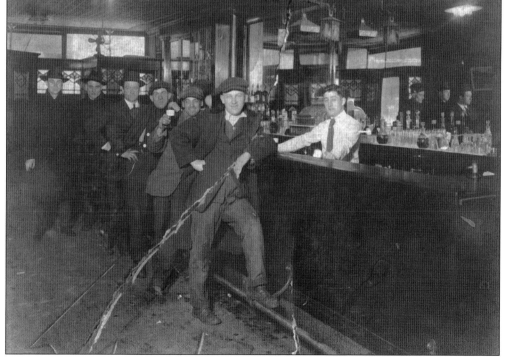

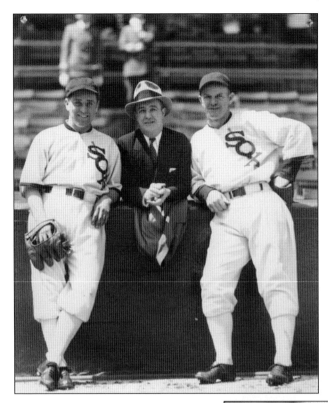

At Comiskey Park in 1935, these men (as identified by Jim Margalus) are, from left to right, Jocko Conlan, Frank Lyons, and Tony Piet. Conlan was inducted into the Baseball Hall of Fame as an umpire in 1974. Frank Lyons is of the McCuddy tavern family. Tony Piet (Pietruszka) played second and third base for the White Sox from 1935 to 1937. (Courtesy of Sherri Senese.)

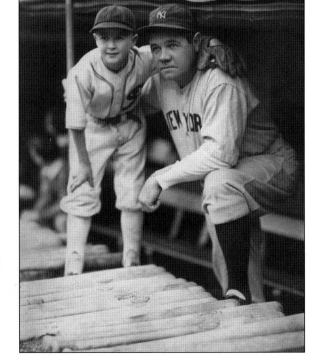

In a Comiskey dugout in 1936, Babe Ruth poses with Pat Lyons, a relative of the owners of McCuddy's tavern. Ruth was known to stop across the street at McCuddy's between Yankee–White Sox doubleheaders for a roast beef sandwich. (Courtesy of Sherri Senese.)

Not only a formidable fielder, hitter, and base runner, Orestes "Minnie" Minoso, also known as "the Cuban Comet," was the first black player to wear a White Sox uniform on May 1, 1951, in a game against the New York Yankees. Loved by fans, the nine-time All-Star won three Gold Gloves and hit for a .389 on-base percentage and .459 slugging average in a career spanning five decades. (Courtesy of Sherri Senese.)

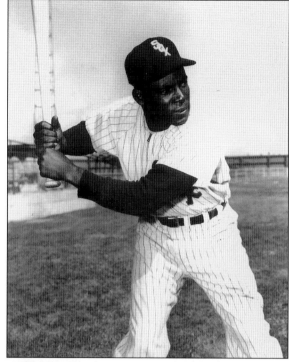

Around 1970, Bridgeport merchant and White Sox fan Bernard Graczyk of 32nd Street and Racine Avenue displays muted enthusiasm for the underwhelming White Sox teams at the turn of the decade. (Courtesy of Jack Lenahan.)

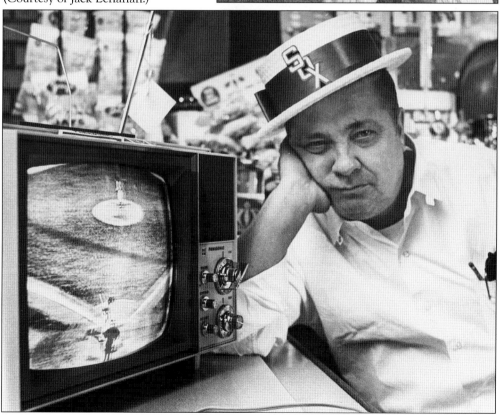

Pictured here are Bill Veeck and Frances McCuddy. Veeck became owner of the White Sox in 1959, taking the team to its first pennant in 40 years. After selling in 1961, he returned in 1975, presiding for six years over a legendary series of promotions and player gambits, the most successful on field being the 90-game-winning 1977 season. The inscription reads, "To Frances - How come you get younger and I get older?" (Courtesy of Sherri Senese.)

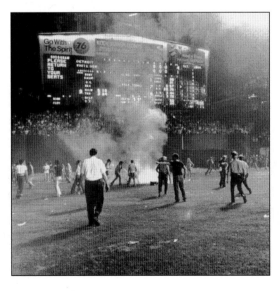

At Comiskey Park on July 12, 1979, radio disc jockey promotion "Disco Demolition Night" goes awry as intoxicated fans storm the field following the explosion of a box of disco records in center field during a break between doubleheader games. "Please return to your seats," pleads the electronic scoreboard. The chaos and damage to the grounds forces a forfeiture of the second game to the visiting Detroit Tigers. The 1970s musical and social phenomenon of disco was used by the promotion to exploit the city's economic and social class divides, granting the presumably working-class White Sox fan the chance to reject disco's bourgeois trappings. (Courtesy of Jack Lenahan.)

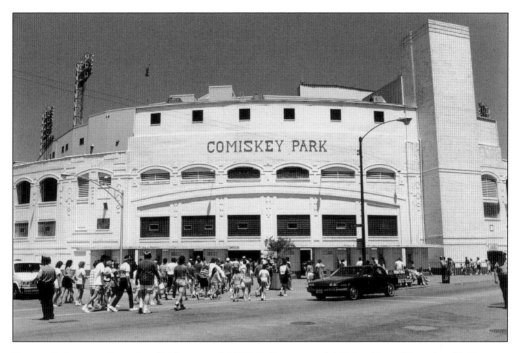

Pictured above is Comiskey Park around 1980. Below around 1990 is New Comiskey Park in an aerial view to the southwest. In 1988, the Illinois General Assembly passed legislation to build and publicly own a new baseball stadium directly across the street from the 1910 Comiskey Park. Scoreboard and bleacher construction in the new park is visibly not finished, giving a probable date to the photograph of 1990. The park was renamed US Cellular Field in 2003. (Both, courtesy of JoAnne Gazarek.)

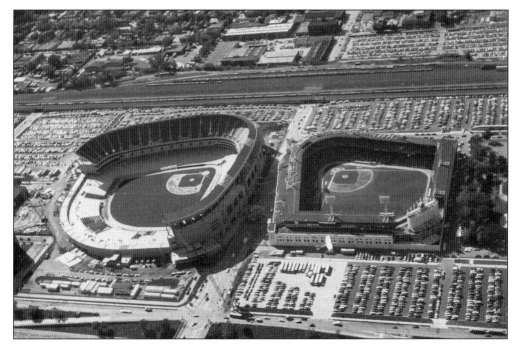

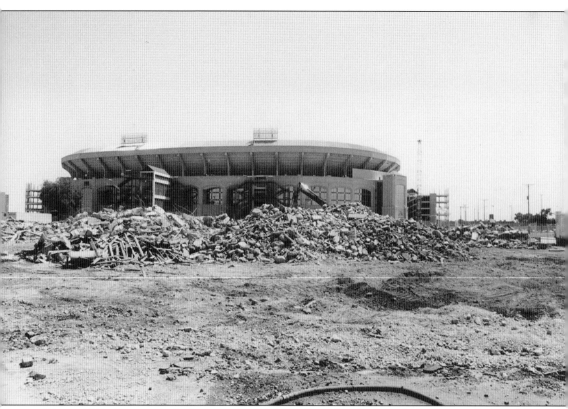

This c. 1991 photograph, looking south with New Comiskey Park in the background, shows the demolition waste from the 1910 Comiskey Park. In 2004, a seven-phase renovation plan was begun on the new park. Its upper deck was removed, eliminating nearly 7,000 seats, greatly improving average sight lines, and reworking the contour's visual aesthetic to a look informed more by classic ballparks. (Courtesy of Jack Lenahan.)

Ten

GONE BUT
NOT FORGOTTEN

Overshadowed like many Chicago neighborhoods by the Loop's luster, Bridgeport is also often overlooked because of its blue-collar stigma. A good look at the area's built environment reveals, however, the abundance of truly impressive architecture to be found here. The Ramova Theatre, countless grand temples, impressive industrial edifices of the Central Manufacturing District as well as intriguing commercial structures are all to be found within Bridgeport's bounds. The remarkable qualities of many of these buildings are all too often lost to the public at large by the familiarity that many of the structures enjoy, leaving them highly vulnerable to demolition. Journalist Mike Royko famously quipped, "Anyone who tries to save landmarks in Chicago is goofy enough to teach celibacy in a Playboy Club or nonviolence to Dick Butkus." Chicago's record on historic preservation leaves much to be desired, and Bridgeport certainly does not differ from that norm.

The vintage photographs included here are sure to bring back memories of buildings and neighborhood institutions, both big and small, that are no more. The images of these local landmarks are sure to stoke memories for older residents in the vicinity as well as help give others an idea of what life was like in Bridgeport in days gone by.

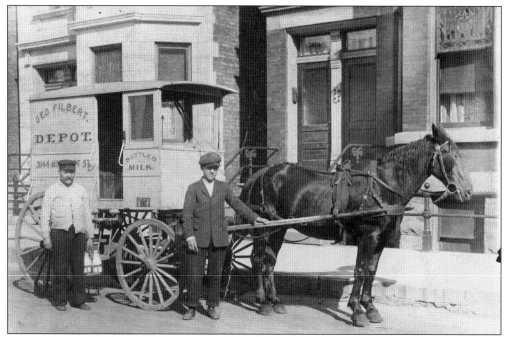

Delivering bottles of milk to the locals via horse and carriage are George Filbert and young son Charlie. George was known to deliver ice, coal, and even provide general moving and transportation services. During the height of Prohibition in 1926, the Filbert family business started brewing draught root beer. Filbert's remains regionally famous for its root beer and flavored pop today. (Courtesy of Ron Filbert.)

Carts and trucks were doing business in Bridgeport long before the modern urban food truck craze. Until at least 1970, there were vegetable and fruit trucks, hot nut carts, knife sharpeners, Stanley and Fuller Brush dealers, and dairy deliveries to one's door. Street peddlers developed a bond with the locals and were considered friends and a welcome and necessary part of the culture. (Courtesy of Charles DiCaro.)

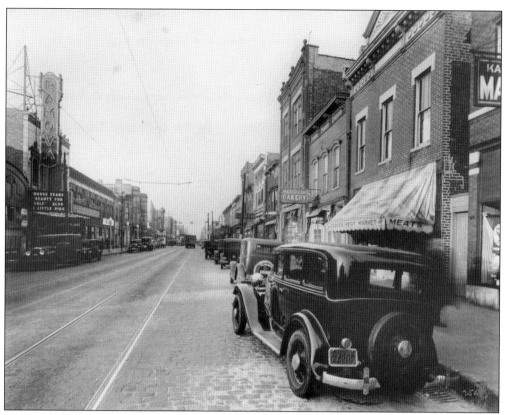

In 1934, 35th and Halsted Streets was the busiest intersection in Bridgeport, the commercial center of Chicago's "Little Lithuania." *Three Little Pigs* is playing at the five-year-old Ramova Theatre, while the former Monogram nickelodeon is shuttered just to its south. The 400-seat Monogram, home of silent films and newsreels, was open from the 1900s to the 1920s, closing before the 1,400-seat Atmospheric-style Ramova opened in 1929. The beloved Ramova closed in 1986, but there is an active effort to reopen it. (Courtesy of Eugene Butenas and the Lithuanian Press.)

The bottom corner unit of this large apartment building was home to Dressel's Bakery, founded in 1913 at 3254 South Wallace Street by German brothers Joe, Bill, and Herman Dressel and one of the most loved businesses in Bridgeport. The family name became synonymous with chocolate whipped-cream cake, lamb cakes, and birthday cakes. Herman stayed on when American Bakeries Corporation bought Dressel's in 1963. Sadly, Dressel's left its original home in Bridgeport sometime in the 1980s. This is the bakery that author Billy Lombardo writes about in *The Logic of a Rose: Chicago Stories*. (Courtesy of Chicago History Museum.)

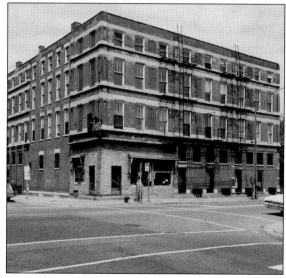

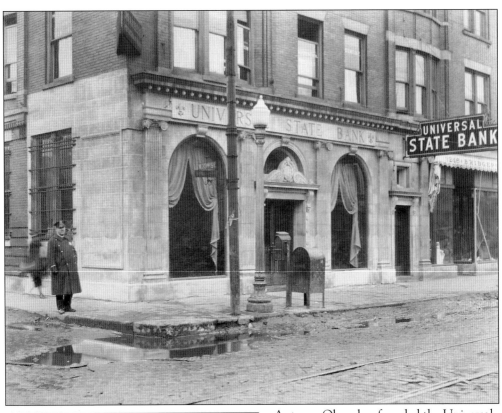

Antanas Olsauskas founded the Universal State Bank, located on the corner of 33rd and Halsted Streets in the heart of the Lithuanian Downtown, as the first bank in Chicago that was owned and operated by Lithuanians. This storefront was also the home of the *Bridgeport News* but now sits vacant. (Courtesy of Chicago History Museum.)

Founded in 1897, the District Savings and Loan on South Halsted Street served the community until well into the 1940s. After it closed, Lithuanian restaurant Healthy Foods occupied this space from 1938 until closing in 2010. Known as one of the oldest Lithuanian restaurants in the world, Healthy Foods is missed by all fans of "*Kugelis* . . . Breakfast of Champions." (Courtesy of Steve Badauskas.)

Budrik, located at 3455 South Halsted Street, was the neighborhood's largest appliance and furniture store. This photograph shows the building's lovely Art Deco storefront in cobalt blue and bronze firebrick. The building was split into two storefronts after Budrik moved. From the 1960s to the early 2000s, the building was home to Georwge's Famous Gyros and a liquor store. Today, the building is boarded up and vacant. (Courtesy of University of Minnesota.)

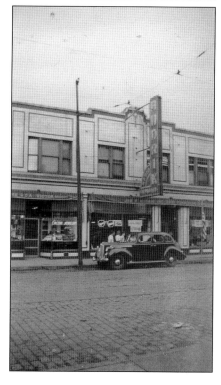

Sometime in the 1940s, Budrik Furniture and Appliance moved two blocks north to 3247 South Halsted Street. After Budrik closed sometime in 1960s, the building was occupied by Tony's Produce until the early 1990s. In 2005, Ace Bakery moved from its longtime home across the street into this space and expanded its business. This is one of the many commercial buildings on Halsted Street that has remained consistently occupied. (Courtesy of Steve Badauskas.)

This shot from the 1980s shows Healthy Foods, opened on 32nd and Halsted Streets in 1938 by Grazina "Gina" Biciunas-Santoski's family. It served "healthy" Lithuanian staples such as *koldunai* (sausage dumplings), *blynai* (rich pancakes stuffed with cheese and fruit), roast duckling, and the dense potato-and-bacon pudding known as *kugelis*. Sadly, Healthy Foods closed in December 2010 when Gina retired. This closure marked the demise of the last Lithuanian traditional business on the old downtown strip. (Courtesy of Grazina "Gina" Biciunas-Santoski.)

One of the most beloved neighborhood restaurants, David's was at the corner of 31st and Halsted Streets. It was founded by Peter and John Maniatis and named in honor of their father. Originally a soda fountain and later a diner, David's was known for famous concoctions including "Goliath," which is a cream soda that some claim was two feet tall, enormous taffy apples, and great burgers. The family added the Governor's Table, a steak house with a full bar and banquet hall, to host business dinners and parties. David's closed in the 1980s and is reminisced about often. (Courtesy of John and Peter Maniatis.)

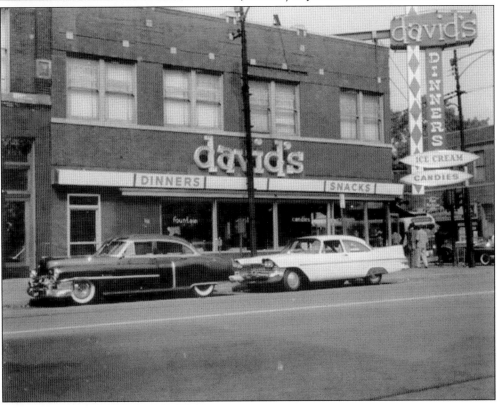

Located at 3142 South Halsted Street, the 900-seat Milda Theater opened in 1914 to show silent films and live performances. The Milda sat across the street from the famous Harmony Club in the Lithuanian Auditorium. It was closed in the 1950s and was then converted into commercial and residential spaces. It was demolished in 2004. Currently, Chicago's first "green" police station occupies this site. (Courtesy of Eugene Butenas.)

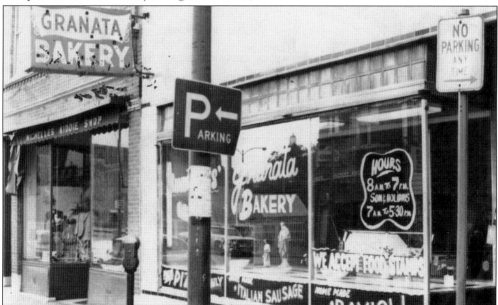

Located at 3320 South Halsted Street, Granata Bakery was known for its delicious pizza and crackling bread that customers could take into the Ramova to enjoy while watching a second-run film. Also famous for its Italian cookies, homemade sausage, and Italian sandwiches, Granata was open at this location from the 1950s until the early 1990s, when it suffered a fire and had to close. The building was demolished, leaving an empty lot that is now owned by the City of Chicago. (Courtesy of Thomas Sr. and Tim Egan.)

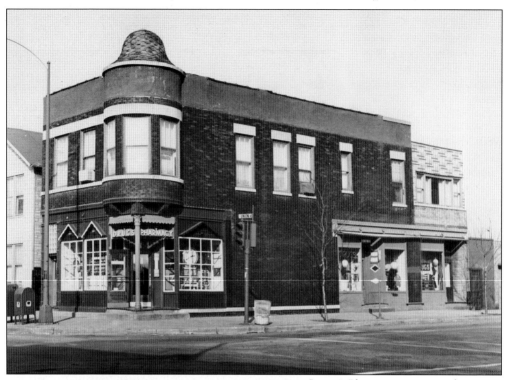

Louie's Pharmacy was a working replica of a 1900s apothecary, which once sold classic remedies such as leeches and compounded drugs. Opened in the 1950s on the corner of 37th Street and Union Avenue, Louie's was a mainstay for Nativity parishioners and their families. Louie's closed in the early 2000s. Today, this building is a residence. (Courtesy of Thomas Sr. and Tim Egan.)

A family-run drugstore and soda fountain founded in the early 1930s, Kunka was a great place for students from St. Barbara and St. Bridget High Schools to take their dates for a soda fountain creation. Kunka's also provided sundries for the whole family's needs. Closed in 2009, this Art Deco storefront today sits vacant on the corner of Archer Avenue and Loomis Street. (Courtesy of Christopher Howard.)

Ricobene's famous breaded steaks and pizza have been a local tradition since 1948 on 26th Street, between Princeton Avenue and Wells Street. It was originally a walk-up window, as seen in this photograph. In the late 1980s, the family enclosed and expanded the stand and then later tore it down after a 100-plus-seat restaurant was built in its place. (Courtesy of Ricobene's Restaurant.)

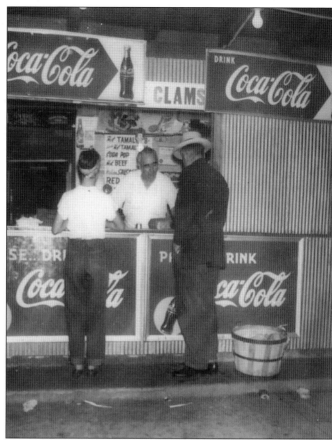

Last, but definitely not least, is the view from the upper deck at the old Comiskey Park. It is gone but never forgotten. Over 15,000 petition signatures and many hours of pleading did not save this old baseball palace from the wrecking ball in 1990. As a memorial, home plate is still in place in the parking lot across the street from the new park. (Courtesy of Chris Bloom.)

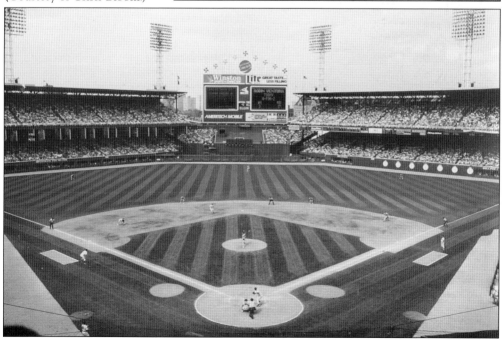

DISCOVER THOUSANDS OF LOCAL HISTORY BOOKS
FEATURING MILLIONS OF VINTAGE IMAGES

Arcadia Publishing, the leading local history publisher in the United States, is committed to making history accessible and meaningful through publishing books that celebrate and preserve the heritage of America's people and places.

Find more books like this at
www.arcadiapublishing.com

Search for your hometown history, your old stomping grounds, and even your favorite sports team.

Consistent with our mission to preserve history on a local level, this book was printed in South Carolina on American-made paper and manufactured entirely in the United States. Products carrying the accredited Forest Stewardship Council (FSC) label are printed on 100 percent FSC-certified paper.

MADE IN THE USA